IMAGES
of America

TOLEDO

A HISTORY IN ARCHITECTURE

1914 to Century's End

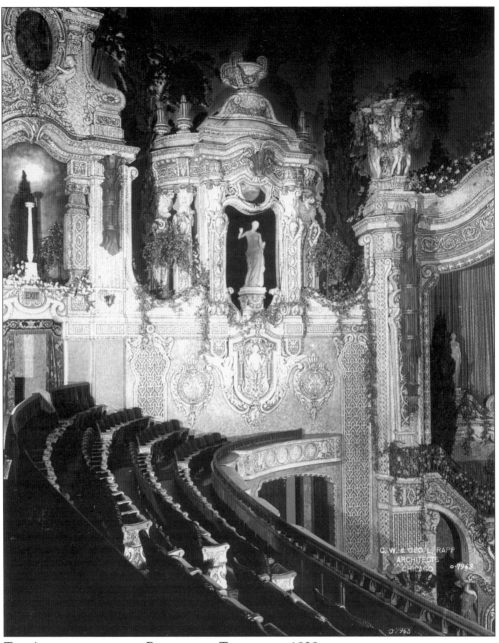

THE AUDITORIUM OF THE PARAMOUNT THEATER IN 1929.

IMAGES
of America

TOLEDO

A HISTORY IN ARCHITECTURE

1914 to Century's End

William Speck

ARCADIA

Published by Arcadia Publishing,
an imprint of Tempus Publishing, Inc.
Charleston SC, Chicago, Portsmouth NH,
San Francisco

Printed in Great Britain.

Library of Congress Catalog Card Number: 2003113356

For all general information contact Arcadia Publishing at:
Telephone 843-853-2070
Fax 843-853-0044
E-Mail sales@arcadiapublishing.com
For customer service and orders:
Toll-Free 1-888-313-2665

Visit us on the internet at http://www.arcadiapublishing.com

*To Claire and Benjamin and Great Aunt Lulu
who took me to the Paramount.*

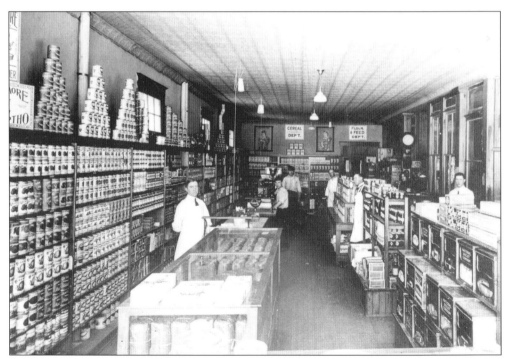

THE STAR GROCERY AT ERIE STREET AND COLUMBUS STREET c. 1915. (PL.)

CONTENTS

ACKNOWLEDGMENTS

Kay Ball, Cynthia and Morgan Barclay, Betty Bennett, Hilda Bentley, Peter and Carol Bentley, Nancy Bernard (The Canaday Center at the University of Toledo), Sarah Bissell, Ben and Peggy Brown, Mimi Butler, Terry DeClerk, Mr. and Mrs. Henry Dodge, Lucille Emch, David Effler, Barbara Floyd (The Canaday Center at the University of Toledo), Fred Folger, Harriet Hamilton, Edward Hill, Edward Hoffman, Hilda Hollyer, Mrs. Henson Jones, Eleanor Kash, Joann Kirchmaier, Mrs. Edward Lamb, Ken Levin, Mrs. Mel Lewis, Peggy Lewis, Charles and Barbara McKelvey, Julie McMasters (Archivist at the Toledo Museum of Art), Betty Mauk, Rose Metzger, Rev. Larry Michaels, Richard Nickerson, Carol Orser, Tom Pederson, Beverly Perkey, Lydia Rhinefrank, Mrs. Robert Roberts, James Robison and Mary Robison Naslund, Bill Robison, George Secor, Robert Shenefield (President of the Toledo Memorial Park), Wayned Siddens, Duffield Sipes, Heather and Jim Speck, Sue and Don Speck, Patrice and Lyman Spitzer, Mimi Stack, Larry Stine, Virginia Stranahan, Taylor Photo, Greg Tye, Horace Wachter, Mark and Melinda Walczak, Jamie Walker, Ernest and Alice Weaver, Matt Wiederhold, and Bill and Sally Williams.

I would also like to thank the staff of the Local History Department at the Toledo and Lucas County Public Library: James Marshall, Greg Miller, Donna Christian, Irene Martin, Mike Lara, and Ann Hurley.

I have abbreviated the names of the collections where some of these photos come from, though the majority come from the Local History Department of the library (PL).

Other institutions that generally lent photos were The Toledo Museum of Art (TMA), The University of Toledo's Canaday Center (UT), and the Firefighter's Museum. Photos not credited come from numerous private collections.

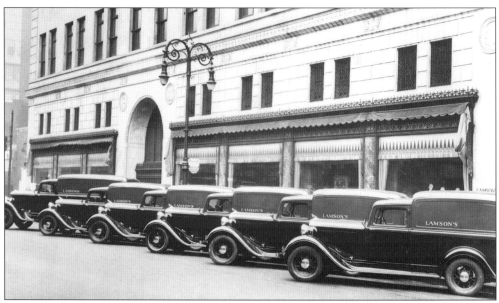

LAMSON'S DELIVERY FLEET PARKED IN FRONT OF THE STORE. (PL.)

INTRODUCTION

Turn of the century Toledo was a self-contained and confident little metropolis where, but the march of progress was about to transform the established patterns of daily life forever. Automobile mass production lead by the Willys-Overland Company turned Toledo into a major automobile manufacturing center, and Toledo's major industries were autos, auto glass, auto springs, spark plugs, electric starters, and transmissions. New types of buildings that had never been built before like auto dealerships, garages, and gas stations appeared.

The soldiers returning from World War I sparked the most boisterous celebration ever seen in downtown Toledo. They had seen much more of the planet than the previous far reaches of Detroit or Chicago and came back with an awareness of the world foreign to self-contained Toledo. The city's sense of isolation was further eroded by the nationwide Influenza Epidemic of 1918–1919 when 1,140 Toledoans died.

Now that an automobile trip took far less time, it became feasible for Toledoans to move outside the old Victorian boundaries of the city. Land along the Maumee River between Rossford and Perrysburg, purchased early in the century for summer homes by Collingwood Avenue millionaires, began being developed into formal estates with enormous Jacobean manor houses and French chateaus that looked like they had been standing for centuries. In West Toledo, Ottawa Hills was founded as a separate village with its own school system, municipal government, and other city services, in a carefully landscaped pastoral setting. Westmoreland, another wealthy development of rolling hills and strict regulations, was also begun at this time, as were more middle class neighborhoods like Old Orchard and Deveaux Park.

The 1920s was the most prosperous time in Toledo's history, and it was a decade when some the city's greatest buildings were being constructed. Lamson's and Lasalle and Koch's built massive Renaissance style mercantile palaces. The Commodore Perry Hotel, with all the luxuries of the 1920s, became Toledo's most fashionable place to stay. Rosary Cathedral, an early Spanish style masterwork by architect John Comes, was being constructed and remains one of Toledo's greatest landmarks.

The new moving pictures, crude and flickering as they might be, appeared more worldly and exciting than a medicine show or a hose company competition. The old pastimes now seemed hopelessly old-fashioned, and movies conveyed a sophistication to small town audiences that before was only read about in magazines. The dramatic rise in women's hemlines—higher than anytime before—was thought to have been popularized by shameless hussy flappers in the movies. The Paramount Theater was the high point in the rise of motion pictures; it was built primarily for movies and was truly a palace in every sense of the word—lavish in every detail and a guaranteed escape from one's humdrum existence.

The foundations of the Ohio Building had barely been finished when the stock market crashed in October 1929. This was Toledo's greatest skyscraper, designed in the most modern style with a show-stopping banking lobby. The Security Home Trust failed to open on June 17, 1931, starting a $100 million run on Toledo's banks. On August 17, four more banks didn't open, including the Ohio Savings Bank and Trust in their brand new headquarters.

The Depression hit Toledo hard. In 1931, half of the workforce was unemployed. Between 1929 and 1935, at least 300 firms failed. The violent Auto Lite Strike took place in 1934. On January 1, 1935, the *News Bee* wrote, "To all of you who are without jobs, who are hungry and distressed, troubled about your children and fearful of the future, we cannot wish you a Happy New Year, but we can wish you a Happier New Year."

Prohibition closed down the old German breweries, and while the largest, the Heubner-Toledo Brewery, tried marketing a low-alcohol "temperance beer" in an attempt to keep Toledo's 175 saloons open, it was soon forced to close. The Depression years were the heyday for organized crime in Toledo with money to be made in gambling and bootlegging and Yonnie Licavoli, Toledo's most dangerous gangster, lived in a cozy cottage in Old Orchard, conveniently close to the state line.

The federally funded Public Works Administration and the Works Progress Administration spent $62 million in Toledo-Lucas County providing employment from 1935 until 1942. During this time, the Zoo was transformed with a series of new buildings, the Main Library was constructed, the Toledo Museum of Art was expanded with additional galleries and the Peristyle. University Hall, Toledo's most recognized landmark was constructed.

World War II revived Toledo's economy with the "Jeep" and other plants producing war related products. Other industries such as Libbey Owens Ford and Toledo Scale continued to prosper, developing innovative new products by some of America's top designers, including the 1943 "Kitchen of Tomorrow."

Toledo Tomorrow, by Norman Bel Geddes and Associates, was a revolutionary 1945 post-war vision of a perfect city with interconnecting transportation terminuses located downtown and a major highway system. While the project, which included a large scale model, was not implemented, it did finally result in a new Union Station.

Toledo's first suburban shopping center, the Colony, opened in the early 1940s. The Westgate Shopping Center, built in 1956, kept even more West Toledoans away from downtown. The advent of television was the death knell for the downtown movie theaters, and the Paramount was demolished in 1965.

The elegant 1960 Libbey Owens Ford Headquarters, by New York architects Skidmore, Owens, and Merrill, was Toledo's first new skyscraper built in 30 years and the first constructed on an open plaza design. Large scale demolitions during the last 50 years robbed the city of much of its architectural heritage replacing it with parking lots, and only rarely have buildings of similar architectural merit replaced them. Fortunately some recently endangered buildings—The Hillcrest Hotel, the Lasalle and Koch Department Store, and the Commodore Perry Hotel, have been renovated as apartment buildings.

After World War II, architecture changed dramatically, and the old tools, particularly the ancient technique of designing a building using mathematical proportions has been largely discarded, and most architects have lost this ability to design buildings with proportions that are naturally pleasing to the eye in favor of more disjointed random designs. This trend is most readily apparent in the somewhat confused-looking mansions of our present day.

The last 25 years has seen a suburbanization of downtown Toledo with too many new buildings built on wind-blown plazas and the unfortunate habit of making renovated buildings stand alone by demolishing all surrounding buildings, thus losing the old streetscape of buildings with adjoining walls, which is the makeup of a city in favor of buildings that look like they belong in a suburban office park.

Several interesting structures have been built recently by big name architects: Ceasar Pelli's Owens Corning Headquarters and Frank Gehry's Education Wing at the Toledo Museum of Art. The Gehrey building has been the object of much controversy in the community, but at least it has revived debate over architecture for the first time in years.

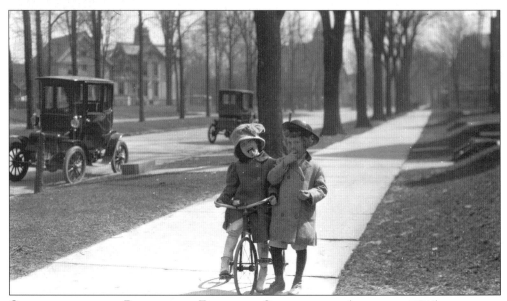

CHILDREN FROM THE RICHARDSON FAMILY ON COLLINGWOOD AVENUE C. 1915.

One

THE WAVE OF
THE FUTURE

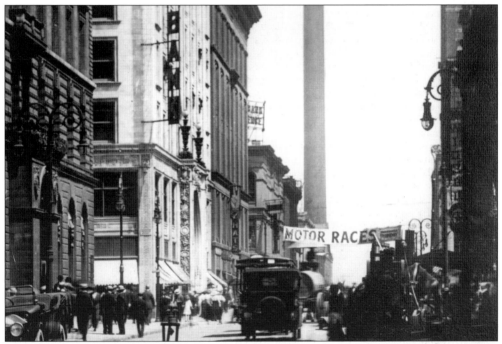

AUTOS ON MADISON AVENUE AT SUPERIOR STREET. Automobiles were an expensive luxury and often unreliable in the first decades of the 20th century. Roads were mostly dirt, and a long trip took one as far as Pemberville, Bowling Green, or Fostoria and back again in one exhausting day. A contemporary source wrote, "Roads were full of thank-you-mams [*sic*], and farmer's cows, and unyielding boulders. Springs were terribly vulnerable it was learned. And country blacksmiths began to dream of great riches repairing mangled wheels." The rich enjoyed showing off their new cars in automobile parades, and the entries in a 1909 parade, "were artistically decorated and represented a lavish expenditure of time and money, Alfred Koch easily out-distanced all competitors . . . (The car) represented a huge yellow butterfly, with gleaming green eyes and waving wings trimmed with a border of electric light." A.L. Spitzer's car wore colonial dress.

Life began to change in 1911 when assembly line production of the model T began, a car for the middle class costing $780. Soon people no longer ran to the front porch when an automobile came by, and the pace of life changed: A critic wrote, "The thing had no thought of a road taken at leisure, tasted, and relished. The thing wished to hustle and dash, not stroll." (PL.)

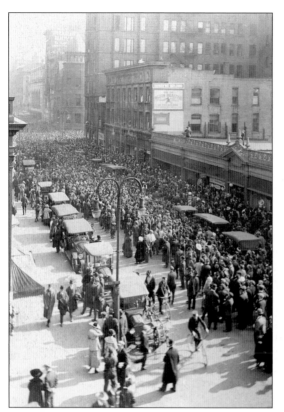

ARMISTICE DAY ON MADISON AVENUE, NOVEMBER 11, 1918. America's entry into World War I was not particularly popular in a city with large German and Hungarian populations, and Toledo's Congressman Isaac R. Sherwood was one of 50 congressmen to vote against entering the war. By the beginning of November 1918 the city was breathlessly awaiting the end, and when the *News-Bee* put out an extra edition on November 7, 1918, declaring that the Armistice had been signed, the city celebrated, but unfortunately the real Armistice was not signed until four days later forever damaging the journalistic reputation of the *News-Bee*.

Doreen Canaday Spitzer wrote, "I was not quite four when the war ended, but my mother was determined that I should never forget this Armistice Day that was to end war forever. So, she said to me, 'I am going to spank you very hard. You haven't done anything wrong. This is not a punishment, it's an emphasis.' She did so, emphatically, and I do indeed remember it." (PL.)

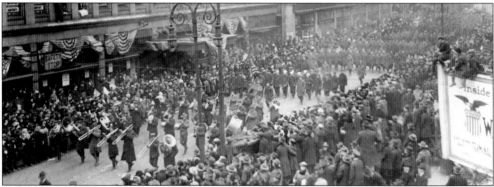

THE ARMISTICE PARADE ON MADISON AVENUE AT ST. CLAIR STREET. Businesses closed, and everyone went downtown for the most raucous celebration Toledo had ever seen. A hastily arranged two-hour parade was followed by hours of "delirious uproar." Everyone tried to outdo each other making noise, "They beat pie pans, or banged wash boilers with hammers. . . . Horns were tooted; whistles blew." One of the cast iron lion statues was uprooted from in front of the Lion Store and dragged down the street. It was one of Toledo's last great occasions when 20th-century citizens publicly displayed an innocent faith in the imminent return of the old days and old ways.

The following day it was reported, "With extra wagons and teams, the street department Tuesday morning began clearing up the debris occasioned by the bizarre demonstrations Monday. They collected papers, books, directories, torn almanacs, tin pans, broken horns, discarded noisemakers, stove (pipe) hats, slogans, and signs. . . . The asphalt in the skyscraper district was ankle deep with relics of the mammoth 'peace victory' celebration." (PL.)

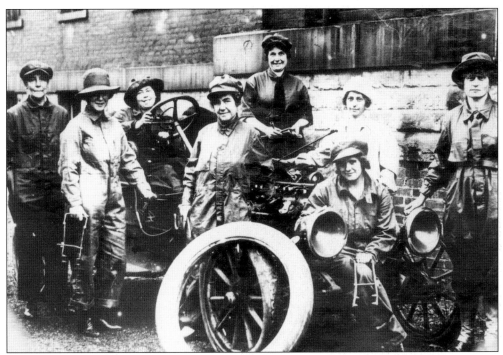

WOMEN'S AUTO REPAIR CLASS IN 1917. World War I gave women some opportunities to take over roles exclusively held by men and allowed them to escape household duties. The Toledo Women's Suffragette Association was first organized in 1869, but women didn't get the vote until 1919. (UT.)

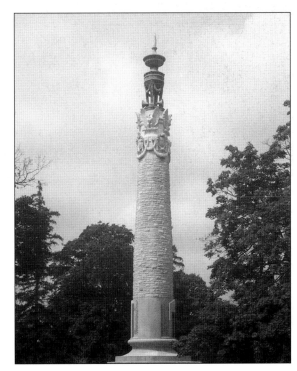

THE WORLD WAR I MEMORIAL AT TOLEDO MEMORIAL PARK CEMETERY. The column was dedicated in 1923 as a memorial to the 330 Toledoans who died. Designed by the T.P. Barnett Company of St. Louis, major battles are listed on the sides, and a leaded glass flame was originally atop the urn.

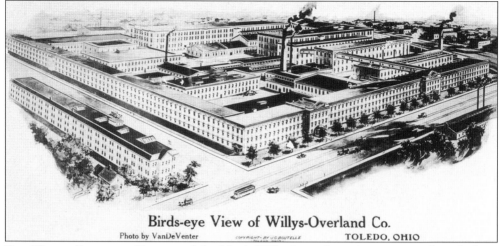

Birds-eye View of Willys-Overland Co.
Photo by VanDeVenter COPYRIGHT BY J.G.BOUTELLE TOLEDO, OHIO

THE WILLYS-OVERLAND FACTORY. John North Willys began his career running a bicycle shop, and he soon opened a separate section in the store for automobile sales. In 1906, he ordered 400 autos from the Overland Automobile Company in Indianapolis, impressed by the car's low price and freedom from repairs. Discovering that the Overland firm was facing bankruptcy, Willys took over the company's debts and contracted to sell the entire year's output. Under his control, the company expanded from producing 465 cars in 1908 to 4,000 cars in 1909. Willys needed a larger plant, so he purchased the empty Pope-Toledo Automobile factory where autos had been produced since 1903. The growth of the Willys-Overland Company continued, and in 1915, it ranked second only to Ford Motors in number of cars produced.

Mills, Rhines, Bellman, and Nordhoff, Toledo's biggest architectural firm, designed approximately 167 buildings and plant extensions for the Willys-Overland Company, and the additions made to Factory Number 45 made it the largest factory ever built in Toledo. Construction began in March 1914; it was completed in 219 working days and required 2,000 carloads of cement, sand, stone, brick, and structural steel.

THE FINAL ASSEMBLY DEPARTMENT AT THE OVERLAND FACTORY IN 1912. Chrysler founder Walter Chrysler once managed the factory, and in 1925, the Overland Company accounted for over a third of Toledo's total payroll. One worker was quoted as saying, "I don't care how you feel about the Overland. I think John North Willys probably influenced more lives than any man who ever lived in Toledo. He brought more people and industry here than anyone I know of."

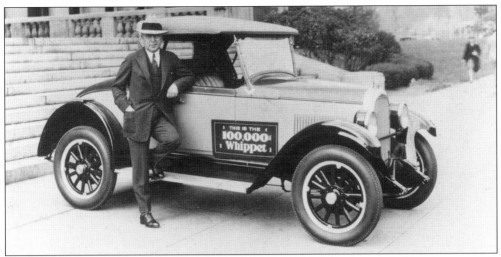

THE 100,000TH WHIPPET OFF THE ASSEMBLY LINE. The Whippet was a light inexpensive car named for a breed of racing dogs and was a big seller. Museum director George Stevens was reported to have pointed out to John North Willys the unattractiveness of the automobile, which carried so much of its machinery visibly. Willys had a sculptor block out masses of an auto of attractive design and had engineers rearrange the parts so working shafts and brakes were less obvious, hence the streamlined car was born—revolutionizing auto design. The Willys-Knight auto was described in an ad as "A symphony of motion—a picture of beauty—a cradle of comfort—a rhythm of power!" The Overland, the Whippet, and the Willys-Knight were popular cars for decades until the Depression when the company was forced into bankruptcy. (PL.)

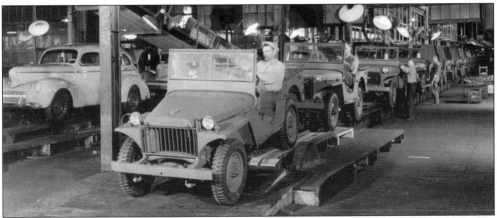

THE JEEP ASSEMBLY LINE DURING WORLD WAR II. In 1936, the company was taken over by Ward Canaday, a former company advertising executive. He rebuilt the company with a new car with new dimensions and styling. The "Jeep," a car "guaranteed for three years or 100,000 miles" was first produced in 1941 for war service by the government, and Willys-Overland was the first auto company to be completely converted to war work, producing over $760 million worth of military equipment, and in April 1944, the 200,000th jeep rolled off the assembly line. The story was told that a farmer who bought one of the used Jeeps, which the army was selling after the war, bumped himself out of it the first time he tried driving over a rough field. He swore that the Jeep went on by itself, turned a big circle to come back, and stopped to pick him up.

The name of the company was changed to Willys Motors in 1953 after it was purchased by Kaiser Industries. In 1963, it became Kaiser Jeep, and in 1969, was purchased by American Motors. (PL.)

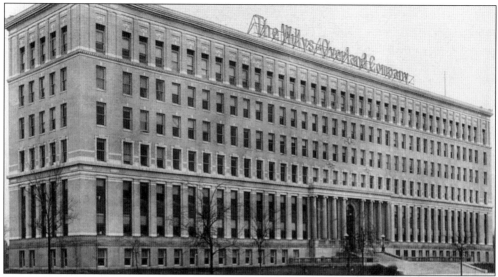

THE WILLYS-OVERLAND ADMINISTRATION BUILDING ON THE NORTH SIDE OF WOLCOTT BOULEVARD, BUILT IN 1914 AND BLOWN UP IN 1979. The administration building was an imposing neoclassical structure resembling many of the government buildings being constructed in Washington at the time and demonstrating a commitment to stay in Toledo. The monumental brick façade topped by a large sign was decorated with stone trim and rested on a raised basement conveying a sense of power. Rows of ionic columns flanked the arched entrance approached by broad stone steps.

By the 1970s, the company headquarters was no longer in Toledo and the administration building sat vacant. Unable to find a new use for it and pressed for parking space, the building was destroyed by being blown up, one of the more impressive fates of any Toledo landmark. (PL.)

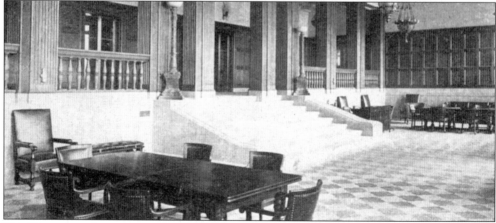

THE ENTRANCE LOBBY OF THE ADMINISTRATION BUILDING. Doreen Canaday Spitzer wrote, "As a little girl I remember being awed when I would visit my father in his spacious office on the fifth floor of the Willys-Overland Administration Building . . . It was brand new and the pride of John North Willys—A crowning symbol of the greatness of Willys-Overland . . . Inside, no expense had been spared. Offices and boardrooms were carpeted in wool and paneled in oak and walnut. Painted tiles decorated the cafeteria. Multicolored Rookwood pottery drinking fountains, and lighting fixtures of bronze were Art Nouveau. Mr. Willys was said to entertain his salesmen with circus performances in the huge auditorium." (UT.)

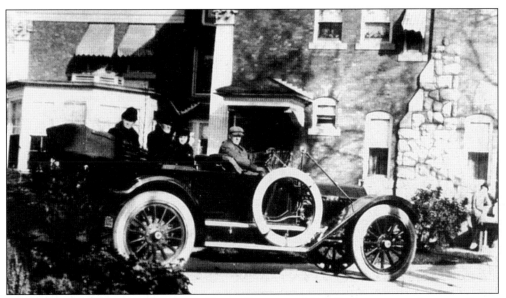

LADIES OF THE DeVILBISS FAMILY BY THEIR HOUSE AT 3015 COLLINGWOOD AVENUE, BUILT IN 1902. The DeVilbiss chauffer sits at the wheel of their touring car ready to take the ladies visiting, shopping, or maybe taking flowers to the cemetery. Dr. Allen DeVilbiss invented the spray atomizer and later successfully developed the atomizer into paint spraying equipment. His son, Allen DeVilbiss, Jr., developed the first springless automatic computing scale. (PL.)

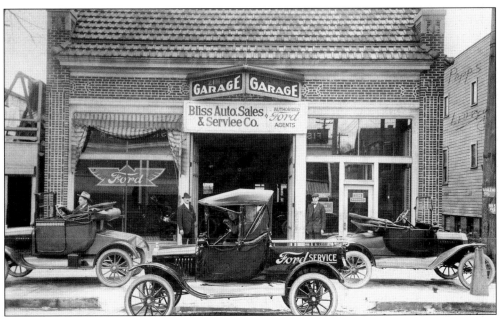

BLISS AUTO SALES AT 320 TWENTY-FIRST STREET, LOCATED HERE FROM 1912 TO 1919. Standing to the left of the doorway is owner Daniel Bliss, on the right is H.E. Francis, the service manager. "Bliss is an expert salesman and one of the most aggressive and enterprising automobile dealers in the city. He started out as a Ford salesman and later sold Hudson and Essex cars. The hitching post for horses at the far right was quickly becoming an anachronism. (Photo by Korb, PL.)

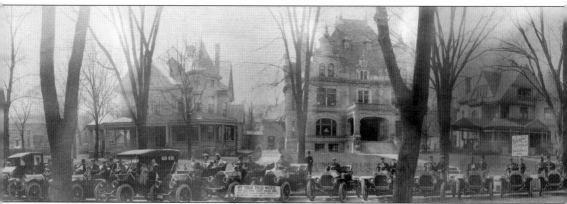

AN ADVERTISEMENT FOR A CAR COMPANY ON COLLINGWOOD AVENUE C. 1915. These are details from a long horizontal photo showing Collingwood Avenue from Monroe Street to Woodruff and Jefferson Avenues. In the center is the 1905 Rudolph Bartley Residence, a huge stone house in the French Renaissance style, and "Innisfail" the colonial revival house

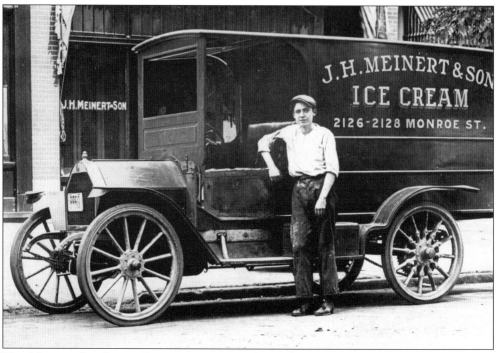

THE MEINERT ICE CREAM DELIVERY TRUCK. The truck and deliveryman stand in front of the headquarters of the ice cream and cake business, located at 2126-28 Monroe Street, and considered by many to be the best in the city.

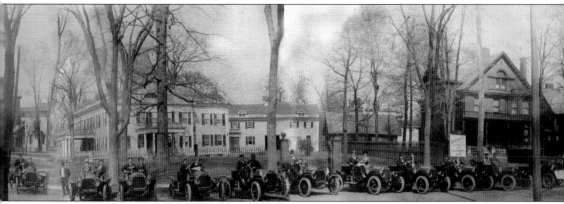

belonging to the Spitzer and Bentley families to the left in the photo.

The sign to the left says, "165 sold this week—ask the man that owns one, 16,000 miles without a dirty sparkplug—ask Gruenwold and Lang the plummers—Overland sold to J.J. Case Co. for salesman's use."

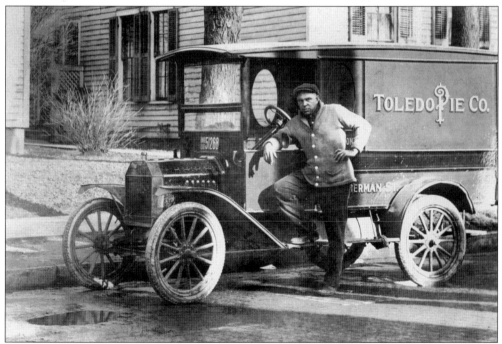

A Delivery Man for the Toledo Pie Company. With motorized delivery trucks, a company's product could be distributed to the far reaches of the city, even as far as the new suburbs of Ottawa Hills and Westmoreland.

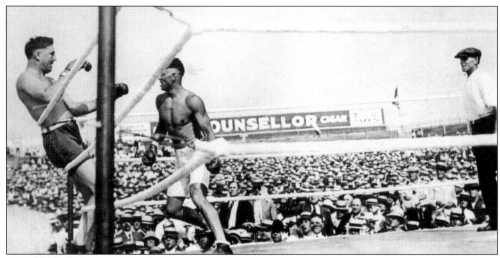

THE DEMPSEY-WILLARD FIGHT AT BAY VIEW PARK, JULY 4, 1919. A 100,000-seat outdoor arena was constructed in Bay View Park for this match between Jack Dempsey and defending heavyweight champion Jess Willard. Willard received a guarantee of $100,000 and Dempsey $27,500. The 95-degree weather kept many away with only about 20,000 spectators willing to pay between $10 to $60 for tickets, and there were 200 reporters present. Dempsey knocked Willard to the canvas seven times in the first round and after a bloody second round, won the crown when the fight was stopped in the third.

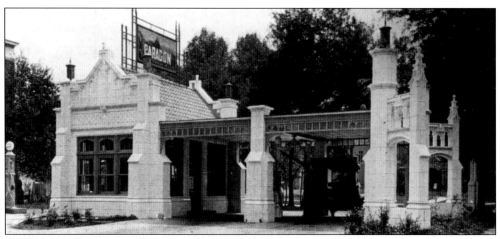

THE PARAGON OIL REFINERY FILLING STATION AT COLLINGWOOD AVENUE AND ASHLAND AVENUE, BUILT IN 1921 AND DEMOLISHED IN 1959. Since the automobile was such a recent phenomenon, architects had no stylistic precedents to fall back on when designing gas stations. The first drive-in station opened in St. Louis in 1907. Architect Manfred Stophlet designed a station in the Gothic style, possibly because the station was located in Toledo's best residential area where an ordinary looking structure would have been entirely inappropriate. The exterior was covered with white tile complete with such historically accurate details as tracery, pointed arches, and incredible flying buttresses supporting the canopy. The uniformed attendants were required to be polite and helpful and to wash the entire building down once a week. The Paragon Refining Company was organized in 1888, with a refinery in East Toledo, and before the company was acquired by Gulf Oil in 1930, it had about 350 filling stations in Ohio and Michigan. This was the only one known to have been designed in this style.

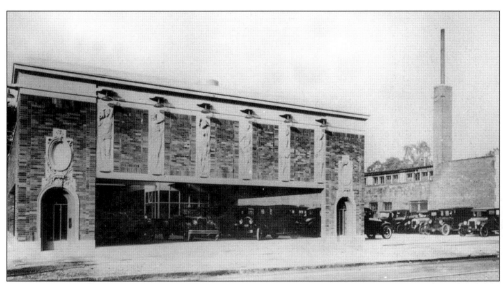

CRYSTAL CORNER, 1211 MONROE STREET, BUILT IN 1927. George Rhinefrank was a highly talented architect, practicing in Toledo during the first half of the 20th century. He was known for his innovative use of materials and having his finger on the pulse of the newest innovations in European architecture. This car dealership won him an award for outstanding design in 1928. Rhinefrank designed a commercial space with no display windows—the glass is gone and the open space pulls in the car shopper to examine the merchandise. The façade has colorful brick decoration accented by carved or cast decoration over the doorways and a series of copies of mid 16th-century French Renaissance statues from the *Fontaine des Innocents* by Jean Goujon.

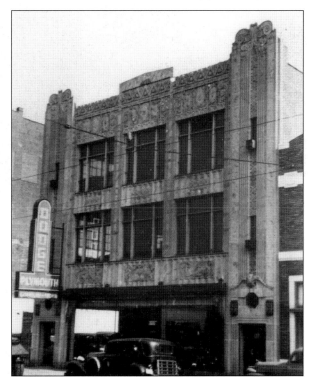

SHORT LOWNSBURY, CHEVROLETS AND BUICKS, 501-03 MAIN STREET, BUILT C. 1926. This former auto dealership is one of the most significant pieces of architecture in East Toledo. It is a classic example of the Art Deco style, and the rest of the city has nothing else like it. The façade is covered with highly decorated surfaces, including the classic frozen fountain motif cascading down each end of the façade, geometric designs at the roofline, and decorative panels below the windows carved in stone. (PL.)

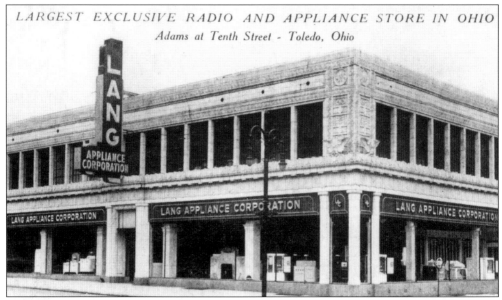

BLEVIN'S AUTO SALES, ADAMS AND ELEVENTH STREET, BUILT IN 1915. Harry Wachter, the architect of some of the Old West End's most interesting homes, designed this auto dealership. The Architectural Terra Cotta Company of Brooklyn, New York provided the façade of cream, matte glazed finish terra cotta at the cost of $4,350. The decoration is very fine, especially the eagles at the corner. The streets of Toledo were still lacking parking meters when this photo was taken; the first thousand were installed in 1936.

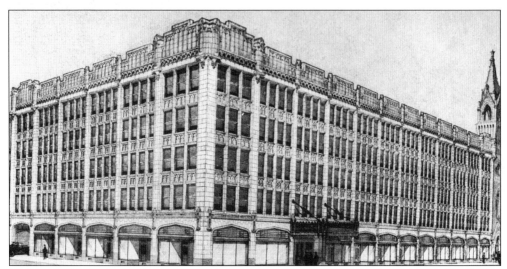

BOARD OF TRADE BUILDING, RICHARDSON PARKING GARAGE, 205 NORTH ST. CLAIR STREET, BUILT IN 1925 AND DEMOLISHED. The Board of Trade Building was Toledo's only large-scale example of the 20th-century gothic revival in the downtown area; it was really a style more popular for school buildings such as University Hall and Scott High. While the white glazed terra cotta covered structure looked like a typical office building, it was really a disguised parking garage. Unfortunately this idea to make parking garages more user friendly to the average passerby by putting in offices and stores never caught on. It was demolished for a totally banal parking garage. (PL.)

Two

REACHING FOR THE SUBURBS

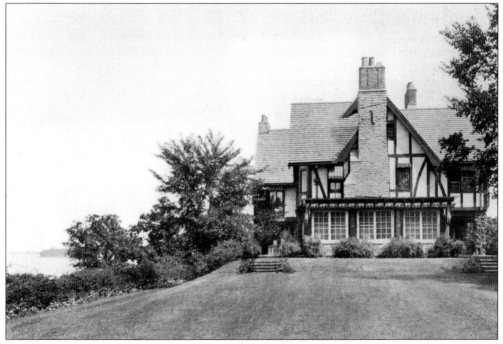

"STONECROFT," THE WILLIAM SPOONER WALBRIDGE HOUSE, 28449 EAST RIVER ROAD, BUILT IN 1917. Built by Edward Drummond Libbey's sister, Alice, and her husband, Stonecroft was described as "a splendid castle on the banks of the Maumee River opposite the site of Ft. Miami." It was one of the first permanent homes constructed along the south side of the Maumee River between Perrysburg and Rossford. Large parcels of farmland were purchased by Toledo businessmen at the turn of the century, and summerhouses were built there. By World War I a daily trip to the city in an automobile took far less time than it once did, so the very wealthy began leaving their Old West End haunts and building enormous homes on expansive park-like grounds. Harry Wachter designed Stonecroft, and the grounds were designed by the Olmstead Brothers firm, sons of Central Park planner Frederick Law Olmstead. The house was later occupied by Harold Boeschenstein, the first president of the Owens Corning Fiberglas Corporation. (Avery Library, Columbia University.)

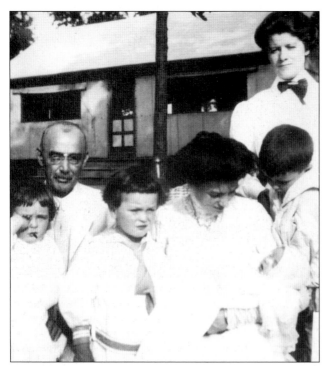

"INWOOD," THE A.L. SPITZER PROPERTY ON EAST RIVER ROAD. The 15-acre property, originally two farms, was purchased in 1909 for $15,000 by A.L. Spitzer. Spitzer predicted that large cities would become places to earn an income, but not places where future Toledoans would want to have their homes and spend their leisure hours: "We will be occupying areas out toward Maumee and Perrysburg, (and they) will be fairly filled with homes of well-to-do businessmen, well paid mechanics, and in fact by almost everyone who realizes that life out in the open where health and peace reign supreme is the only way of really living instead of merely existing in the crowded growing city."

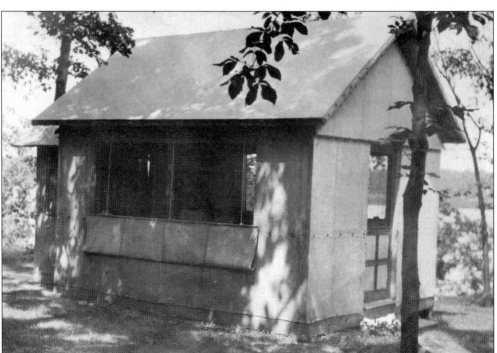

THE SLEEPING TENT AT INWOOD. The Spitzers and groups of their friends would frequently make day trips for picnics and swimming. The original accommodations for longer stays included a living and dining tent and a sleeping tent, which would be disassembled during the winter months. Several houses were later built on the property by members of the Spitzer family.

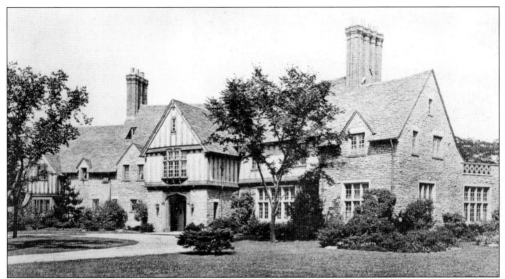

"Graystone," Mrs. Edward Ford House, 28523 East River Road, Built c. 1927.
This was the home of Carrie Ross Ford, widow of the glass giant Edward Ford. They came to Toledo in 1898 and bought land for the Ford Plate Glass Company factory and developed a company town named "Rossford." The Fords lived in a fine house that still stands at Collingwood Avenue and Bancroft Street, but after her husband's death in 1920, she decided to build a river house to be closer to her children's estates. Mills, Rhines, Bellman, and Nordhoff did a skillful job of creating an English manor house that looked like an ancient family seat that had been standing on the site for five hundred years. It was more comfortable looking and welcoming than more pretentious late 19th-century designs.

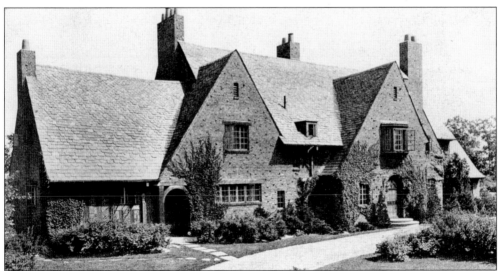

George Pope MacNichol House, 30217 East River Road, Built in 1923–1924. This transplanted Cotswold Cottage exhibited a colorful slate roof, chimneys with chimney pots, lead down spouts, carved wooden grape pendants, half timbering, and irregular brickwork laid in a herringbone motif. Here again, the Mills firm demonstrated a great sensitivity through these details, which enabled them to design a house that looked ages old. Mr. MacNichol became president of Libbey Owens Ford in 1953.

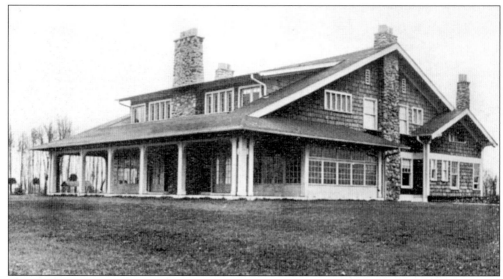

THE FORD COTTAGE, 29455 EAST RIVER ROAD, BUILT C. 1908 AND DEMOLISHED IN 1922. This property was purchased in 1908 for a summer home the year after George Ross Ford, son of Edward Ford, married Grace Williams Miller, and this was the "cottage" they built. The property was part of a group of connected farms owned by the Ford and Knight families known as "Belmont Farms."

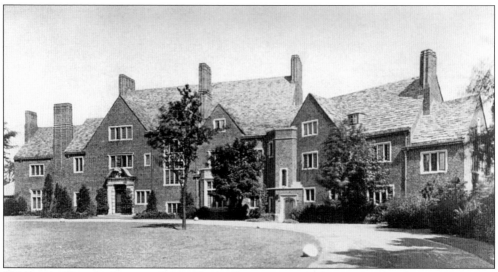

"MILLFORD," THE GEORGE ROSS FORD HOUSE, 29455 EAST RIVER ROAD, BUILT IN 1922–1933. The original house was demolished in 1922 for construction of a permanent family home on the same site. The Mills firm designed a sprawling reinforced concrete structure resembling a Jacobean mansion with brickwork laid in a diamond pattern with stone trim, a roof of thick irregular slates punctuated with gables and massive clustered chimneys, and a fine stone doorway with columns topped by a broken pediment. The 20,000-square-foot, 57-room mansion reputedly cost $450,000 to construct and has long been considered the largest house ever built in the area. Ford died in 1938 at the age of 56, his wife died in 1965, and in 1970, the house was on the market for $250,000. It was later converted into three separate residences with great sensitivity to the house's original features.

24

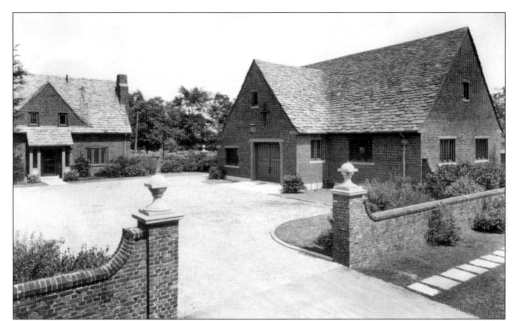

SOME OF THE MILLFORD ESTATE OUTBUILDINGS. This view shows the garage and caretakers house. There was also a gatekeeper's cottage and a guesthouse, and the exteriors were built with the same eye for detail as the main house. The estate employed a staff of 40 with 10 live-in servants and its own telephone switchboard. It also had a sick room with a germ-proof door where several operations were performed on Mr. Ford.

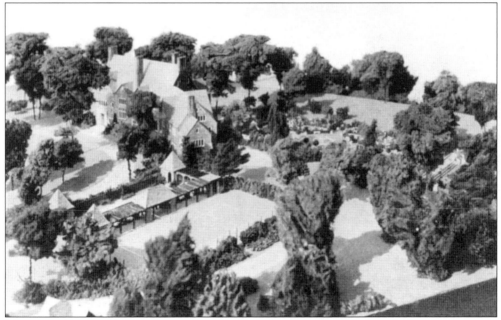

MILLFORD ESTATE LANDSCAPING. Landscape architect Albert Taylor of Cleveland made a one-sixteenth-inch model of the house and grounds, meticulously showing where every bush and tree should be planted. The tennis court in the foreground was apparently never built. (Avery Library, Columbia University.)

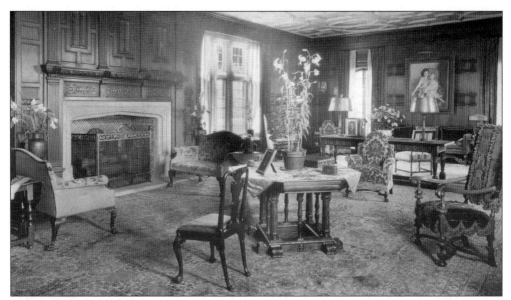

THE LIVING ROOM AT MILLFORD. A New York decorator designed the principle rooms on the first floor, and a separate decorator was hired to do the rooms on the second. The living room was richly paneled in carved oak with a decorated ceiling, and the fireplace was one of 13 throughout the house. The furniture was a mixture of antiques and reproductions with little interest in creating period rooms with furniture pushed up against the wall, but rather in creating a 20th century design suited more for comfort with furniture placed in groupings.

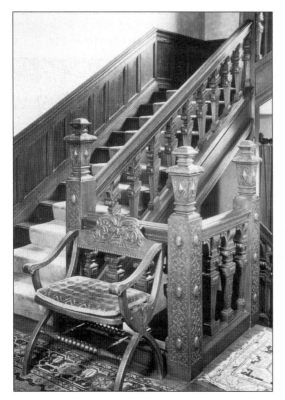

THE MAIN STAIRCASE. The front hall was a relatively small, unassuming space, and one must walk through the music room to get to the stairhall. Here one sees further evidence of the fine oak carving reminiscent of early 17th-century English country houses.

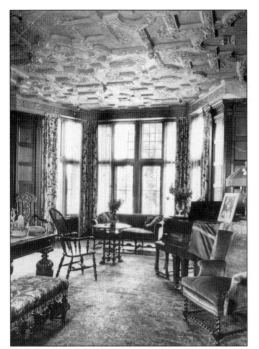

TWO VIEWS OF THE MUSIC ROOM. The ceiling of the Music Room was the finest in the house with royal coats of arms and elaborate strap work with hanging pendants and an equally decorative cornice just below. A built-in pipe organ is partially hidden by the carved oak screen. A room on the second floor was designed as an exact replica of a captain's cabin on a ship with curving, hull-shaped plank walls, a fireplace with iron doors, and amber-colored leaded glass windows with bubbles that resemble sea spray, looking out on painted seascape backdrops.

THE LIBRARY. This room had less of the historically correct detailing than the other principle rooms did. A painting by Toledoan Edmond Osthaus of a man reading in a tavern surrounded by his dogs hangs over the fireplace. All of the interior photos are by Mattie Edwards Hewitt of New York and were probably taken soon after the house was completed.

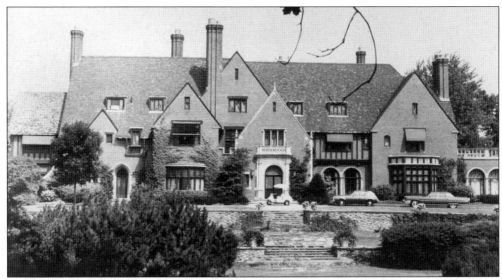

"BELLE ALLIANCE," THE GORDON MATHER HOUSE, 30027 EAST RIVER ROAD, BUILT IN 1924–1927 AND DEMOLISHED IN 1985. At age 18, Gordon Mather started his own business, the Cleveland Axle Company, to develop more durable springs for early automobiles. He moved to Toledo in 1911 and founded Mather Spring—the largest automotive spring plant in the world, and only Mather springs were used in Model T's. Mather and his wife Charlotte left their Collingwood Avenue home in 1927 for this 16th-century style English manor house. Designed by Mills, Rhines, Bellman, and Nordhoff, it sat on 20 acres of grounds, which included a formal garden with a reflecting pool and a gatehouse. (PL.)

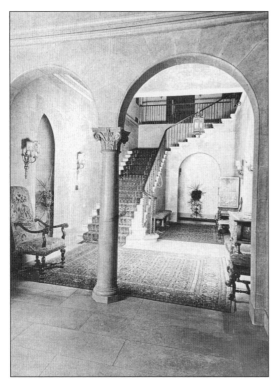

THE STAIRHALL. This photo shows the stone hall looking into the stairhall, separated by two arches and a stone column. There were 23 main rooms in the house with servants' rooms on the third floor.

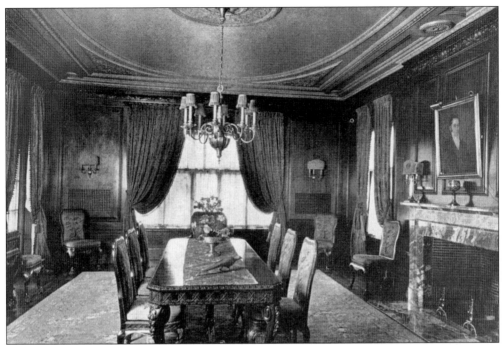

BELLE ALLIANCE DINING ROOM. The paneled dining room was late 18th century in style with simplified decorative details and a less elaborate ceiling. The Georgian style chairs were covered with needlepoint, and the table, also early 20th century, has fine carved legs. A Portrait of Mr. Mather's grandfather Richard Mather hangs over the fireplace.

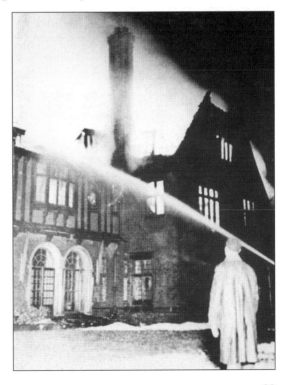

THE FIRE. On January 5, 1936, one of the Mather children got the bright idea to burn the Christmas tree in the library fireplace. The burning tree overheated the library chimney and flames spread through the attic. Edward Knight, a son of neighbor W.W. Knight, out flying in his plane, was one of the first to see the flames and tried to buzz the house to attract the Mathers' attention. The second and third floors were extensively damaged in this $200,000 fire, but because of reinforced concrete construction the first floor emerged relatively undamaged; firemen reported that during the height of the fire, everything was peaceful in the library, and the fire in the fireplace was still burning brightly. (Photo by Norman Hanzen, Fire Fighters Museum.)

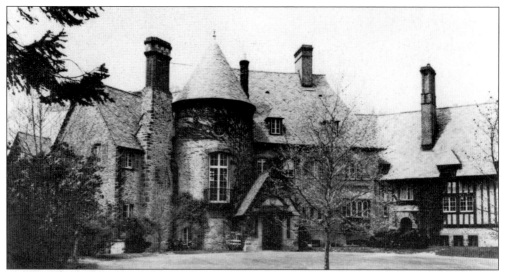

"WAMSTON," THE FRANK STRANAHAN HOUSE, 29917 EAST RIVER ROAD, BUILT IN 1925–1930. Brothers Frank and Robert Stranahan brought their budding sparkplug business from Boston to Toledo in 1910 to take advantage of the Midwestern automobile market. They had spark plugs they wanted to sell to John North Willys, but he refused to buy from a supplier in Boston. Finally at Willys' urging, they transported their entire business to Toledo in two boxcars. The brothers developed an inexpensive replaceable plug, and they persuaded gas stations to supply them to customers. The company became the world's largest manufacturer of spark plugs by 1914; in 1916, they sold 14 million; and by 1917, they opened their first foreign plant.

Cleveland architect Charles Schneider, best known as the architect of Stan Hywet Hall in Akron, designed this French Norman style house for Frank. The design was a brilliantly conceived arrangement of stone, brick, and half timbering with a massive tower with conical roof enclosing the staircase and an interesting interplay of window shapes and sizes on the façade. (PL.)

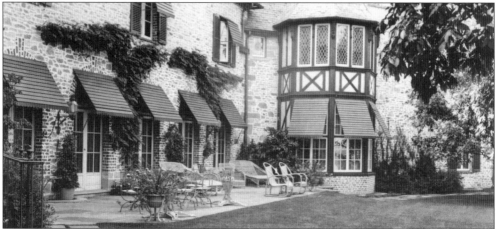

THE RIVER SIDE OF WAMSTON. A loggia on the riverside connected the principle first floor rooms and created a cloister-like effect. Schneider also designed a gatehouse, stable, and greenhouses on the property. The Olmstead brothers of Brookline Mass designed the grounds and fine gardens and built mounds to create vistas. A nearby farm was purchased for its topsoil and fully grown elm trees were transplanted to the site. The grounds had a 300-foot alle—a walk covered by a dense canopy of specially trained trees. (PL)

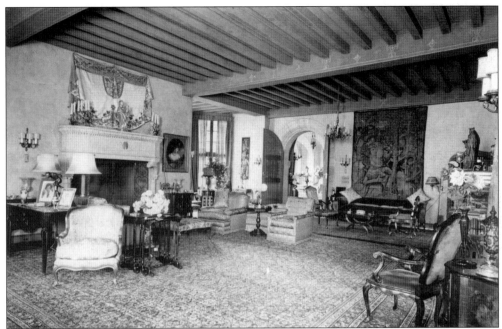

THE WAMSTON LIVING ROOM. Helen Irwin, a society decorator from New York, was hired to design the interiors. The living room was full of objects collected by the Stranahans on their many travels. There are tapestries and gothic sculpture, Bohemian glass, and 18th- and 19th-century furniture from continental Europe. Mrs. Stranahan liked to hold musical events here and entertained many of the rich and famous when they visited Toledo. Gertrude Stein was a guest here in 1934 and was given a jeweled spark plug. (PL.)

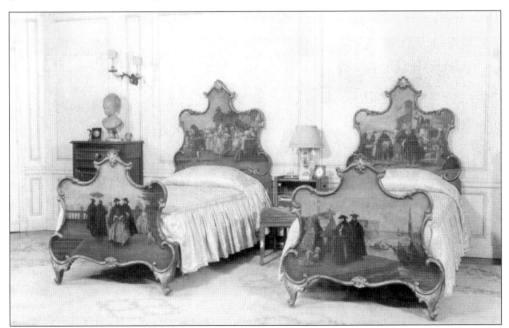

A WAMSTON BEDROOM. Another souvenir of their travels were these Venetian baroque style beds painted with carnival scenes. (All Photos by Ray Bossert, PL.)

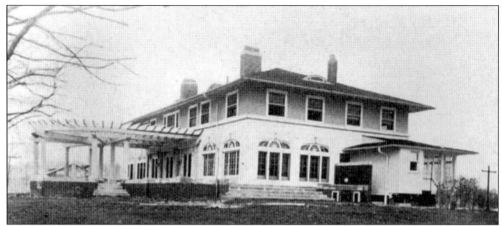

"Belmont Farm," the Knight House, 29447 East River Road, Built c. 1917. This is a rear view of the house built for W.W. Knight and his wife Edna Ford Knight. Designed by Harry Wachter, it was a sizable frame building covered with stucco though still in the "summer cottage" tradition. Arched windows and the large round pergola enlivened an otherwise undistinguished house, and the pergola was later glassed in for a sunroom. Knight purchased the Bostwick Braun hardware company in 1904. He was also a banker and member of the Federal Reserve Board in Cleveland, and an important figure in financing, corporate organizing, and directing. According to family lore he was credited with saving Toledo Trust from failure during the Depression by turning up the heat so high in the banking lobby that depositors standing in line couldn't take it and went home instead of withdrawing their money. He was also a civic leader and did much towards the development of Toledo's park system. (PL.)

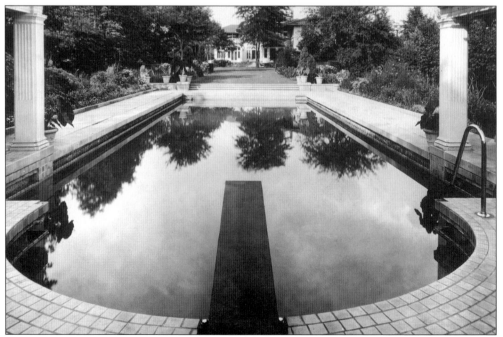

The Belmont Farm Swimming Pool. This was one of earliest private swimming pools in the area. Wood columns support a pergola similar to the one on the house. Part of this pool was incorporated into a new house on the site many years later. (PL.)

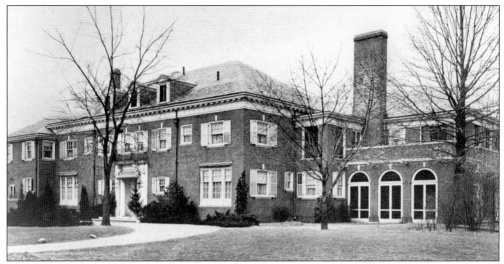

BELMONT FARMS. The original wood house was remodeled and refaced with brick by the Mills, Rhines, Bellman, and Nordhoff firm sometime in the 1930s giving it an English Georgian appearance though their was no serious attempt at historical accuracy. After the death of Mr. Knight at the age of 90 in 1968, the house was demolished the following year, and the site became part of "The Hamlet" housing development.

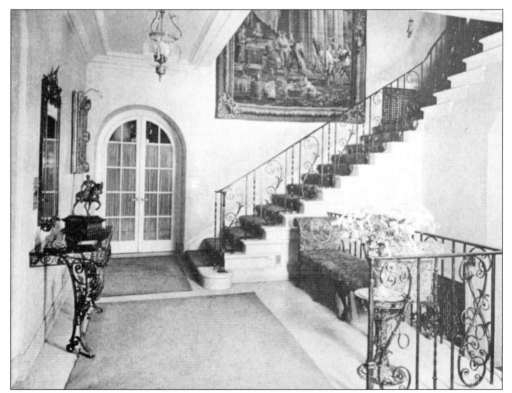

BELMONT FARMS, STAIRHALL. The stair railings and console table were by celebrated metal artisan Samuel Yellin. Some of this ironwork was reused at another river estate after the house was demolished.

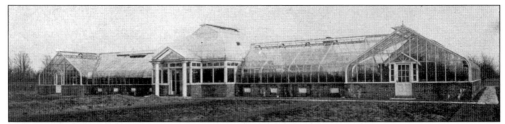

THE BELMONT FARM GREENHOUSE. Many of Toledo's large estates had their own greenhouses, and this one was designed by Mills, Rhines, Bellman, and Nordhoff in 1923. Mrs. Knight loved orchids, and the house was always filled with flowers. (PL.)

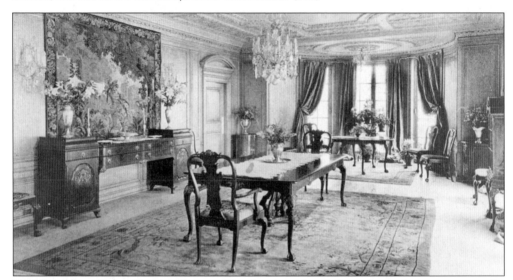

THE BELMONT FARM DINING ROOM. The furniture dated from about the same era as the construction of the house and is currently located in the dining room of another Perrysburg estate. A large formal dining room always had two tables—one with enumerable extensions for large dinners and a smaller breakfast table near the window for four or less. The rooms decoration recalled English Georgian interiors of the early 18th century.

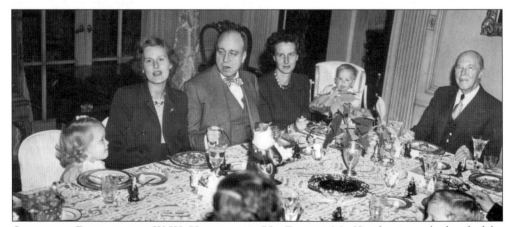

CHRISTMAS DINNER WITH W.W. KNIGHT AND HIS FAMILY. Mr. Knight sits at the head of the table in this photo from the late 1940s.

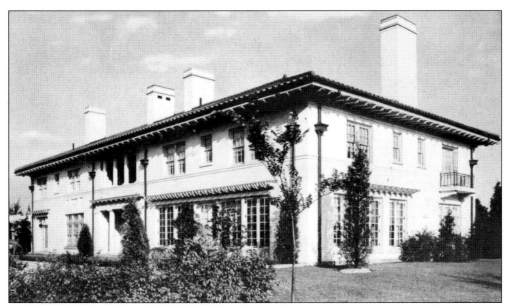

THE BOCK HOUSE, 500 RIVERSIDE DRIVE, EAGLE POINT COLONY, BUILT C. 1918. William Emil Bock was a farm boy who became a machinist and later went to work with Michael Owens inventing the bottle machine. From 1899 until 1910, he was second in command, and many of Owens' patents list him as co-inventor. He later invented the "Bock (taper roller) Bearing" and a machine that could both wash and dry laundry. He died practically penniless during the Depression. (Avery Library, Columbia University.)

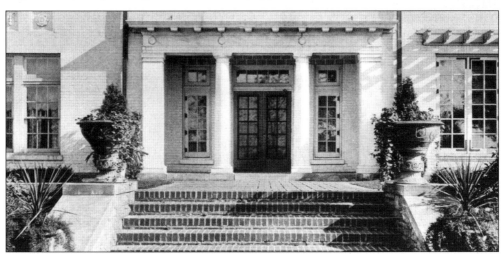

THE BOCK HOUSE ENTRANCE. Bock's impressive house was located in the Eagle Point Colony, a World War I era planned community located just to the south of Rossford. George Rhinefrank was the architect of most of the early homes. This house had a Mediterranean feel similar to houses being built in California at the time—low to the ground with a tile roof. The balcony and open porch on the second floor and trellis for vines above large first floor windows break down boundaries between the indoors and out. Bock was very interested in nature and "the sunken gardens of his beautiful home on the Maumee River were a showpiece." Bock commissioned the bronze statue of naturalist John Burroughs on the grounds of the Toledo Museum of Art. (Avery Library, Columbia University.)

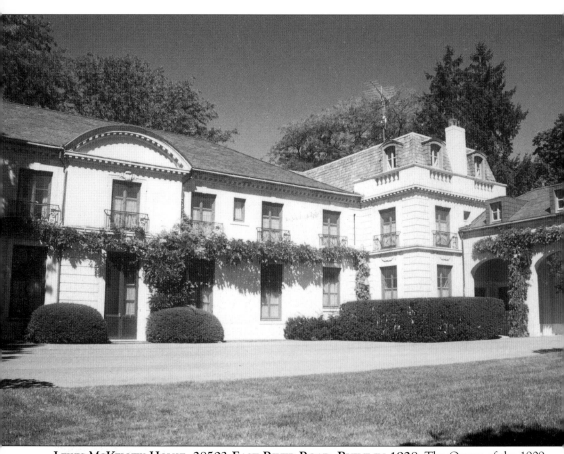

LEWIS-MCKELVEY HOUSE, 28503 EAST RIVER ROAD, BUILT IN 1928. The Queen of the 1909 Wamba Festival, Ethelyn Chesbrough Lewis, built this house the year before the stock market crash. She was one of Toledo's social leaders and taste makers for many years, and her house was certainly a reflection of this. It was modeled after La Lantern, an 18th-century house at Versailles. The house is limestone, two stories tall and seven bays wide, topped by a low hipped roof with a central entrance crowned by a carved stone pediment. A relatively unknown George Walling was the architect of the house, and his design was not an exact duplicate: some decorative details were simplified, and the central pediment was simplified and curved instead of pointed. The service wing and garage to the right were later additions. The approach to the house is magnificent—through a gateway topped by peacock statues and down a straight drive bordered by trees.

Ethel married attorney Frank Lewis, but she had no strong interest in the activities that other society ladies engaged in. She was interested in photography and had her own darkroom, she opened a dress shop in the 1920s and in the 1930s wrote articles for the *Toledo Times*. The Lewis family was forced to sell the house after the Crash, and they moved downtown where Ethel and her servants ran a Madison Avenue hotel. After her husband's death in 1947, she moved to New York where she married Louis Cates head of the Phelps-Dodge Corporation. She had homes in New York, Paris, Monaco, St. Croix, and Haiti, but until her death in 1979 at age 89, she always said that she liked Toledo best. She would attend parties at her old house in later years with no signs of regret. Her sense of taste was inherited by her granddaughter Chessy Rayner, a New York decorator considered one of the best-dressed women in America for almost 50 years.

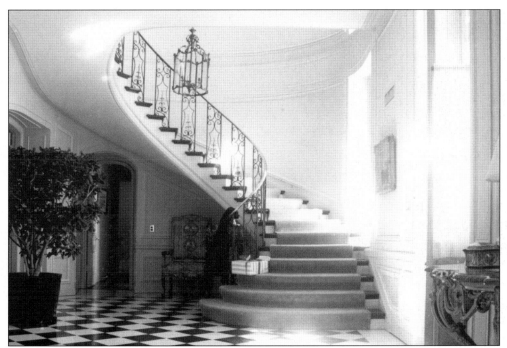

THE STAIRHALL. The iron railing on the graceful staircase complimented the fine iron balconies on the exterior. The house was sold to Lockhart McKelvey in the early 1930s. McKelvey was a Pennsylvania businessman with banking interests who married coal company heiress Margaret Gosline in 1924. The house remained in the McKelvey family for over 60 years.

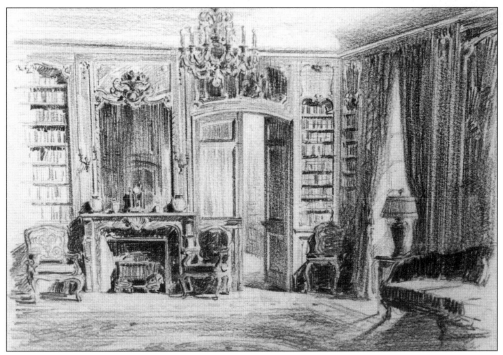

AN ARCHITECT'S RENDERING OF THE LIBRARY IN 1931.

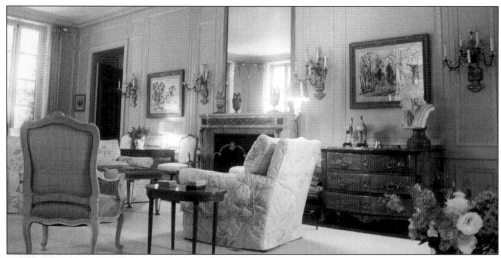

THE LIVING ROOM. The room was described in the 1930s: "The wood wall panels with beautifully designed moldings in the style of Louis XVI are painted a pale shade of gray, and the parquet floor is covered with a heavy hand tied carpet in soft gray tones . . . on one side of the room is a charming mantel piece of rose marble ornamented with bronze doré mounts and above it is a tall mirror . . . the room is lighted with appliqués exquisitely fragile in design . . . entwined with a graceful vine with leaves in crystal and gilt."

A number of important paintings hung in this room after World War II. Margaret McKelvey, under the tutelage of museum director Otto Whitman, purchased primarily French art of the 18th century and the Impressionist era, and she bequeathed a number of her paintings to the Toledo Museum, including Henri Matisse's *Dancer Resting*.

THE PAVILION. Toledo decorator Clare Hoffman took a year to design this tent-roofed solarium addition in the 1950s, which opened up the living room giving the house a closer relationship to the fine gardens. The ceiling of the room resembled the inside of a tent.

THE PRUDDEN HOUSE, 26281 WEST RIVER ROAD, BUILT C. 1935. Karl Hoke was the architect of this romantic English Tudor house of brick and half timbering with diamond-paned, leaded-glass windows, scalloped bargeboards, and a tower with a pointed roof. P.P. Prudden headed the Toledo investment firm of Prudden and Company, and this house was built after his retirement in 1935.

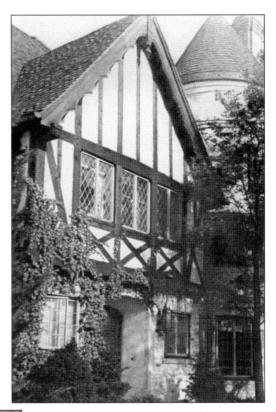

THE PRUDDEN HOUSE STAIRHALL. The stairs were unusual as they had open risers with scrolled decoration and a simple railing. Clare Hoffman was hired to decorate the house. He began his career in 1924, working at Radcliffe's Interior Design Studio and later opening a decorating shop on Madison Avenue. He had clients all over the country besides his wealthy Toledo ones. Mrs. Margaret McKelvey said, "I do get mad at Clare, but dammit, he is always right. There just is no one with his knowledge, his scope, his style, his ability. . . . Once he had outlined how a house, a room, or even one chair should be treated, it's as if an oracle had spoken."

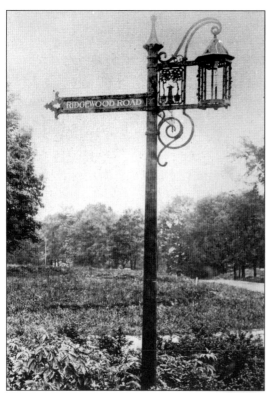

A Combination Lighting Standard and Street Sign, Orchard Road and Ridgewood Road. Originally part of the swampland that made up most of northwest Ohio, the area was drained in the 1840s and was farmed for 75 years. In 1913, the area was surveyed by E.H. Close for a real estate development. Close had experience planning private communities, having already developed Bronson Place. With financial assistance from John North Willys and Paul Harsch, a total of 1,200 acres was purchased for the establishment of an incorporated village of less than 5,000 people with its own municipal government and its own school system and police and fire departments. This superb piece of street furniture beautifully decorated with trees and a sundial demonstrated the kind of picturesque lifestyle Close was trying to create.

Steps by Ten Mile Creek. The Olmstead Brothers firm was hired to plan the landscape, and they were sensitive to the rolling hills and mature trees, and 35 of the first 100 acres was devoted to parkland. Here they created a series of terraces and steps of varying shapes and materials. The landscaped hillside off of Ridgewood Road, one of "the lovingly curved streets," was designed with a fountain built of iridescent tile imported from England. "Above the creek," one long time resident said, "was this magnificent fountain and a waterfall and goldfish pond. Flowers were planted everywhere."

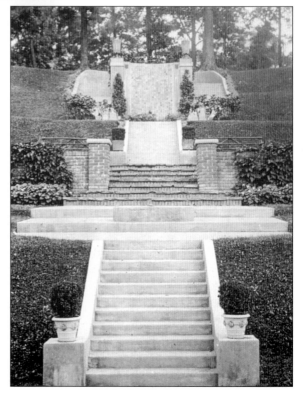

THE BELDON HOUSE, 3404 BROOKSIDE ROAD, BUILT IN 1918. In 1916, house construction was begun in Plat I, an area of 100 acres encompassing Orchard, Brookside, Edgevale, Ridgewood, and Hawthorne Roads and Canterbury Court. The residential development was rigidly restricted: "Every home erected must conform to a standard in design, in location, and in cost." There were no sidewalks built until villagers protested in the late 1920s. It wasn't until 1936 when sewers were constructed; before that, sewage flowed directly into Ottawa Creek past the University of Toledo Campus. (Photo by Korb, PL.)

BOATING IN OTTAWA HILLS. Ten Mile Creek was full of canoes during the summer and skaters during the winter. Promotional materials praised the landscaping: "The river banks have been dressed gracefully to the water's edge." There were ambitious plans for digging five lakes, a bathing pavilion, and a golf course, but these were never carried out. "Its hills and woods shut out the hurry and confusion of the big city and offer in its place a life of laughter and contentment."

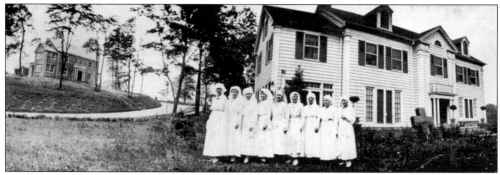

THE NAGEL HOUSE, 2105 HAWTHORNE ROAD, BUILT IN 1919. William Nagel, the owner of an electric company responsible for electrifying many of the 19th-century buildings of Toledo, was the first owner of this frame colonial revival house. The volunteers standing on the lawn manned a Red Cross station here after World War I. The house up the hill to the left at 3626 Edgevale was also built in 1919 and first owned by lumber dealer Barga Leach. (Village of Ottawa Hills.)

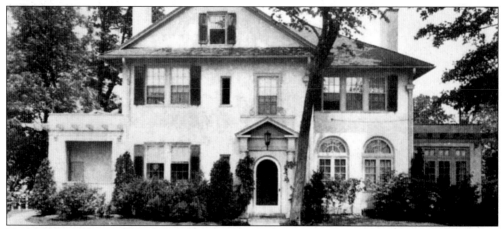

THE BROER HOUSE, 3534 RIDGEWOOD ROAD, BUILT IN 1916. This was one of the earliest houses built in Ottawa Hills. It was designed with wide overhanging eaves, arched windows, and a doorway with neoclassical details. William F. Broer was employed in his families jewelry business.

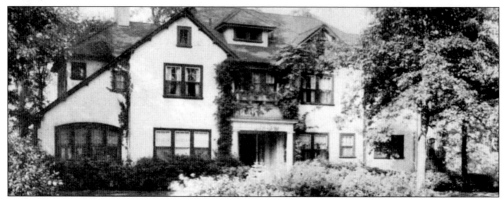

THE BAUMGARDNER HOUSE, 3584 RIDGEWOOD ROAD, BUILT IN 1924. Ned Baumgardner was from a Toledo family prominent in the 19th-century dry goods business. The house was ample, but it had the feel of a country cottage with simple proportions and detailing.

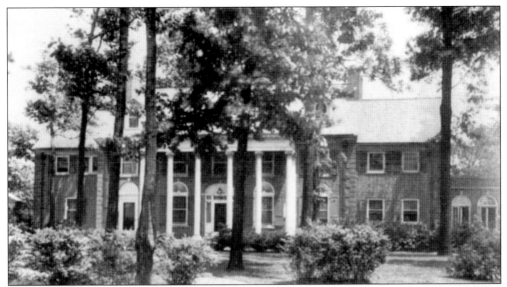

THE CLOSE HOUSE, 3574 RIDGEWOOD ROAD, BUILT IN 1918. This house was designed for Ottawa Hills developer E.H. Close by the prominent New York architectural firm of Starret and Van Vleck, who were designing the Lasalle and Koch Department Store on Adams Street at the same time. It was a substantial brick structure with a front porch supported by six pillars. One early resident recalled, "Halloween was fun. You got the most wonderful treats in Ottawa Hills—I mean, big, whole Milky Way candy bars, and one family always gave out dimes."

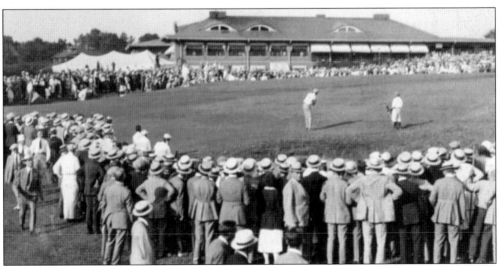

INVERNESS COUNTRY CLUB, 4601 DORR STREET, CLUBHOUSE BUILT IN 1919–1920. Inverness was founded by a group of Ottawa Park golfers who purchased Dorr Street farmland over two miles from the end of the trolley line. This was the third clubhouse on this site, the first one burned in 1911, only eight years after construction, and the second lasted only six years before it too burned. Mills, Rhines, Bellman, and Nordhoff finally persuaded the members to build a brick structure, and their design was unobtrusive and low to the ground; it didn't try to overshadow the beauty of the golf course. The building has undergone many alterations. The Club accepted its first female member in 1903. It has hosted four U.S. Opens, two PGA Championships, one U.S. Amateur, and one Senior Open. (PL.)

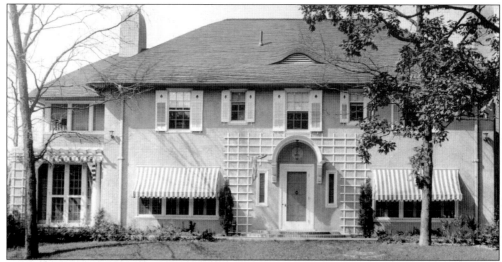

THE CAUFFEL-WILSON HOUSE, 4144 RIVER ROAD AT FLINT STREET, BUILT IN 1916. The Copland family owned 442 acres since the 1840s, just south of the Miami and Erie Canal below the city limits. A Copland descendant began subdividing the area and naming the plats after himself, opening Copland Heights and Copland's Riverview addition in 1911, Arden Place in 1913, Copland Place in 1924, and Copland Woods in 1928. The Toledo Country Club is located on former Copland property. The cauffel house was designed by Mills, Rhines, Bellman, and Nordhoff. The stucco exterior of the house was decorated with windows of many different sizes, some with shutters, some with awnings, and lots of decorative trellis work. The chimneys look almost organic—like mushrooms growing out of the roof. (Photo by Korb, PL.)

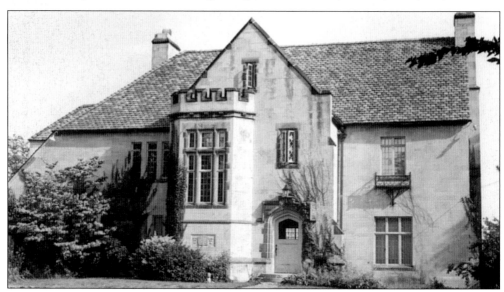

THE HANKISON HOUSE, 2908 RIVER ROAD, BUILT C. 1926. The Hankison House was one of the more castle-like designs of the era, it has a fortified appearance complete with a large crenulated bay with leaded glass windows and the Hankison family crest carved in stone below. The entrance hall has a wrought iron stairway and a fountain with pool in the center, decorated terazzo floors, and wrought iron gates. Otto Hankison was an attorney and trucking firm operator, and he tried in vain to prevent the Ohio Turnpike Commission from putting a road through his property.

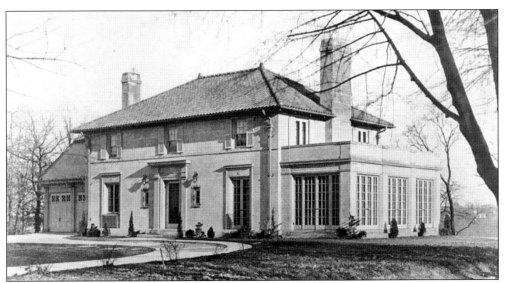

THE WEARLEY HOUSE, 4335 RIVER ROAD, BUILT IN 1927. Another house designed by the Mills firm was this stone Italianate-influenced residence with characteristic features such as a tile roof, small windows on the second floor, and long windows on the first floor with fine ironwork balconies and window grills on the windows flanking the front door. O.D. Wearley was the local distributor for Packard automobiles.

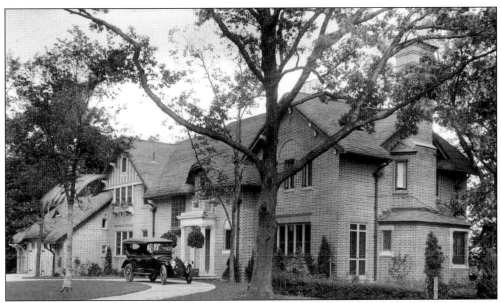

THE EARL HOUSE, 4215 RIVER ROAD, BUILT IN 1916. One of Toledo's great houses was built for Clarence Earl, a vice president at the Willys-Overland Company. The Mills, Rhines, Bellman, and Nordhoff firm designed a highly picturesque house with patterned brickwork laid in the Flemish bond pattern, and the curved roof shingles cleverly suggest a thatched roof. There is a leaded glass bay window at the stair landing, the roof is supported by brackets, and a simple neoclassical porch with Tuscan columns frames the entrance. A house having an attached garage was an innovative feature. Landscaping too was important with lots of shrubs, window boxes, and topiary trees by the doorways. (Photo by Korb, PL.)

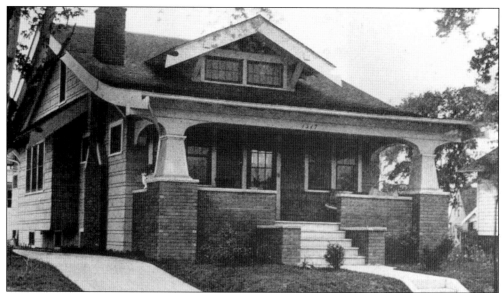

THE MOTTEN HOUSE, 1517 WAVERLY AVENUE, BUILT IN 1917. The Carl E. Mehring Company was a major builder of speculative houses, and in 1917 alone, they built 250 houses and duplexes. Their advertisements promoted these middle class houses as being a great savings to the homebuyer: "Plans for your home are furnished absolutely free. Wallpaper, chandeliers, hardware, and all the small things that enter into the home are shown you before you purchase one of our homes."

A TOLEDO DUPLEX. This unidentified duplex was a generic design that could have been built in many parts of the city after World War I. It had identical floor plans, each with a small front porch. This popular design enabled the property owner to be both an investor and landlord.

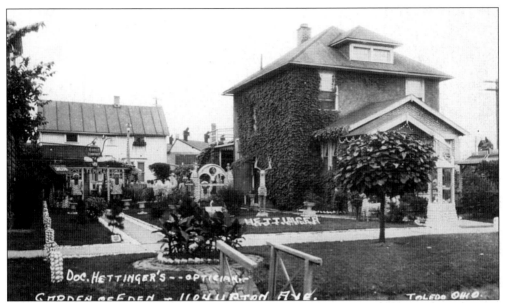

HETTINGER'S "GARDEN OF EDEN," 1104 UPTON AVENUE, BEGUN IN 1919 AND BULLDOZED IN 1969. The idea for this assemblage was inspired by three visions reported by the Pentecostal minister and optician in 1919. Doc. Hettinger interpreted these visions, including the first of walking under the surface of the sea and being lured by mermaids to a house with a garden of shells. He began collecting thousands of shells from Reno Beach, and he would get up at 4 a.m. to work on his creation. He decorated his house, garden, and garage and built and decorated a small chapel. The inside of the chapel, his "House of Visions," was covered with paintings ranging from Biblical scenes to a picture of a team of horses getting hit by a train.

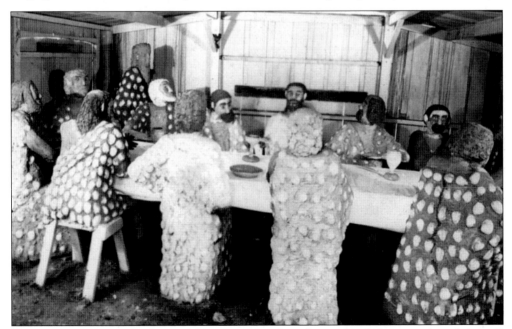

THE LAST SUPPER. The faces of Christ and his disciples are brightly painted, and they all wear shell-covered togas.

47

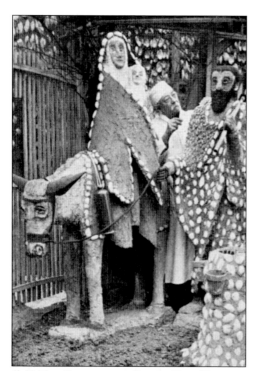

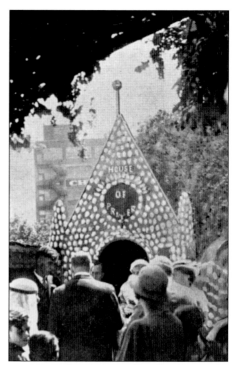

(*left*) **THE FLIGHT INTO EGYPT.** Doc. Hettinger in his customary white coat and hat hitches a ride.

(*right*) **THE CHAPEL.** Also known as the "House of Visions," the chapel was advertised as the smallest in the world. Doc. Hettinger's House of Visions became a pilgrimage site for people from around the world, but neighbors began to get peeved at the constant flow of visitors to the shrine at all hours and by the lack of restrooms and parking facilities. Cassius M. Hettinger died in 1955 at a time when no one thought of his creation as folk art. It was totally demolished about 15 years later.

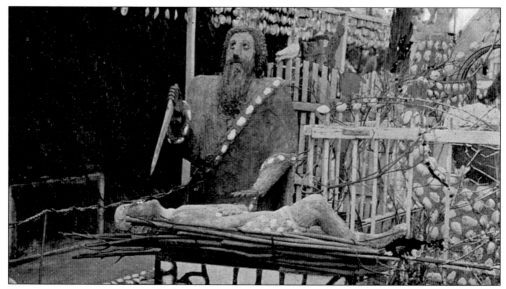

THE SACRIFICE OF ISAAC. Abraham looks up to the heavens as he prepares to sacrifice his son, wearing a shell-covered sash and cuffs with rows of sea shell wind chimes in the background.

Three
THE RISE BEFORE
THE FALL

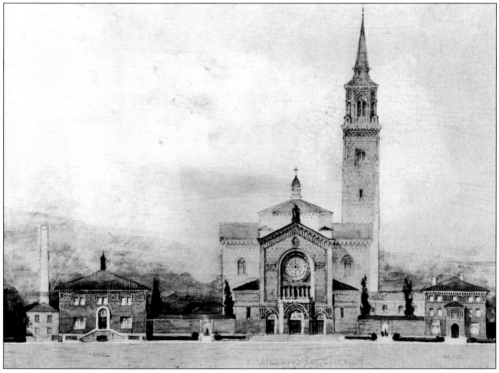

ROSARY CATHEDRAL, 2535 COLLINGWOOD AVENUE, BUILT IN 1925–1931. Toledo's Cathedral church, St. Francis de Sales was a fine mid 19th-century structure but it didn't convey any real sense of grandeur, and by the beginning of 20th century, the Bishop was calling for a replacement. This early elevation drawing from 1912, the first of some 20 future revisions shows a much different design from what was finally built. The majestic tower was never constructed due to the Depression. The parish house fronting Collingwood Avenue to the right was constructed only to be picked up and moved to the rear of the complex in 1925. The cornerstone for the church was laid in 1925, but the final design wasn't completed until 1927. The church was finally dedicated in 1940, though services had been held there since 1931. John Comes, a member of the Pittsburg firm of Comes, Perry, and McMullen was chosen as the architect, and Rosary Cathedral is considered the crowning achievement of his career; a career cut short by his death in 1922 at age 49. (PL.)

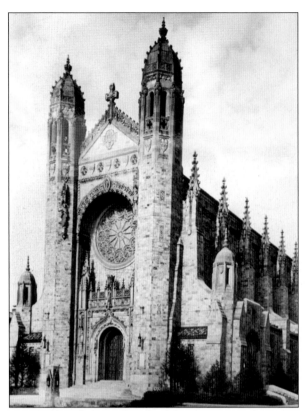

ROSARY CATHEDRAL. John Comes was a man of strong faith, and his specialty was church design in Romanesque and early gothic styles, but a recent California commission gave him the opportunity to see Spanish inspired Mission architecture first hand, and he designed the Cathedral in the Spanish Plateresque style, meaning "ornamentation resembling a silversmith's work," gothic-inspired, carved stone decoration and classical touches such as Palladian arches filled with gothic tracery. The structure was built of granite and limestone in the traditional manner. The recessed arch was a favorite Comes motif. Between buttresses are a series of bas-reliefs depicting the history of the church in the old world and the new.

The interior seats 1,500 with a long vista of the nave and a finely decorated Spanish ceiling, a baldachino over the altar, and a rose window dedicated to the life of Mary. Modern materials were used for decorative elements like the aluminum railings and the baptismal font hood. Wood carvers were still at work as late as 1948. The fine use of rich materials was most impressive, and the whole design suggests the promise of higher achievement. The Cathedral is a modern building that expresses the simplicity and power of the faith of the early church. (PL.)

ROSARY CATHEDRAL SCHOOL, BUILT IN 1914. The school was also designed by John Comes and demonstrated his talent for combining materials that compliment the warm mellow glow of the cathedral walls and the red orange and yellow colors of the tile roof. This side view shows rows of windows separated by pairs of chimneys with yellow brick laid in decorative patterns. (PL.)

St. Anne's Church, 1119 Bancroft Street, Built 1924–1926. The neighborhood known as Auburndale was platted and developed in 1874. The parish of St. Anne's was organized in 1898 by Rev. J.H. Muellenbeck with 250 families of Irish, German, and Belgium extraction. Ten lots were purchased at Bancroft Street and Forest Avenue, and the most important structure, a school designed by Toledo architect Thomas Huber was constructed in 1899 (it is the oldest school still in use in

Toledo), and the Notre Dame Academy was constructed across the street in 1904.

Architect John Comes' second Toledo church was designed in the Lombard Romanesque style. Groundbreaking ceremonies took place in 1924. The plan of the church is cruciform in shape with an 118-foot campanile, which is almost free standing, and a porte cochere on Forest Avenue. The building was constructed of granite with Sandusky limestone trim. At the top of the façade is a Calvary group carved in a six-ton block of stone hoisted into position in 1925. In 1960, the parish took in two black parishes, St. Martin de Pores and St. Benedict de Moor. Much of the parish was lost due to late 1960s expressway construction. The church, now known as St. Martin de Porres, is an architectural gem overlooking an architectural wasteland.

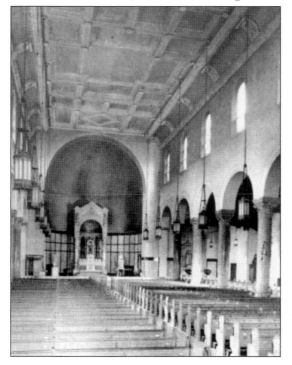

The Interior of St. Anne's Church. Architect John Comes death occurred during construction: "He imagined our beautiful edifice with a clear view. Fortunately he had already completed a well defined plan of our St Anne's before he became afflicted with the lingering illness, which caused his premature death." Renowned architect Ralph Adams Cram said, "The great work of restoration in Catholic Church architecture has been accomplished largely by . . . John Comes whose death last year was a tragedy both for the church and for us who remain."

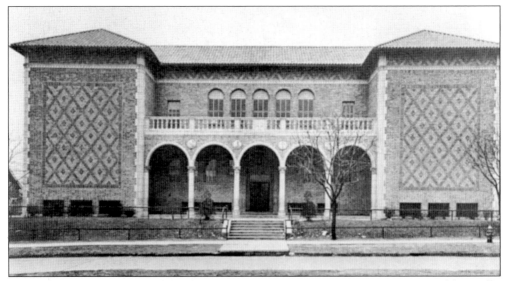

ST. AGNES SCHOOL, 3891 MARTHA AVENUE, BUILT C. 1923–1926. Designed by Mills, Rhines, Bellman, and Nordhoff, this structure exhibits some of the finest decorative patterned brickwork on any Toledo building. It is a simple design with two windowless wings decorated with diamond motifs, connected by a loggia with Renaissance inspired columns and arches, surmounted by a cornice decorated with a decorative brick triangle motif.

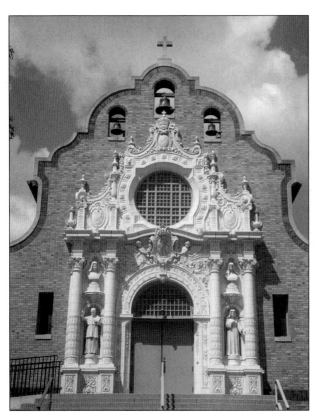

MONASTERY OF THE VISITATION, 1745 PARKSIDE BOULEVARD, BUILT IN 1916–1918. The Monastery is a strict cloistered order where the nuns in residence have had practically no contact with the outside world. The Panama-California International Exposition, under the supervision of renowned ecclesiastical architect Bertram Goodhue, popularized a new, much more elaborate version of the mission style decorated with the rococo fantasies of Churrigueresque architecture of Mexico and Spain translated into newly developed white terra cotta. It's not known if the splendid doorway crowded with its statues, busts, cherubs, urns, and cartouches was designed by architect Joseph Hahn or whether it was ordered as a stock item from the Brooklyn Terra Cotta Company.

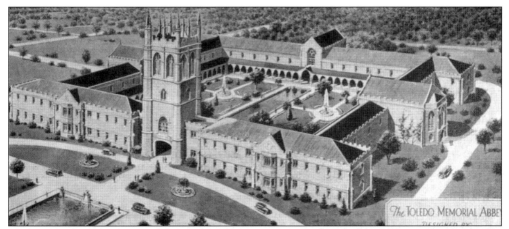

TOLEDO MEMORIAL PARK CEMETERY MAUSOLEUM, 6382 MONROE STREET. The original design for the mausoleum was described as, "representing the highest conception in dignity of architecture . . . the 'Last Word' in Mausoleum construction." The structure was to be constructed of reinforced concrete faced with granite with a marble interior. It would hold spaces for 4,360 bodies with three chapels, a 352-foot tower with chimes, and a 90 by 40 foot garden court pool. The Depression brought construction to a screeching halt with only the foundations and cellars dug. A much reduced version was completed in a neoclassical-Moderne style faced with less expensive travertine, located at the end of a reflecting pool known as Swan Lake (though no swans have been in residence in over 30 years). The chapel has a barrel vaulted ceiling decorated with cherubs and embellished with decorative carved gothic style angels over doorways and a gothic style window meant to be used in the original unrealized design. The enormous abandoned cellars, known to generations of Sylvania youths as the "catacombs," were a favorite hangout until their demolition in the early 1990s.

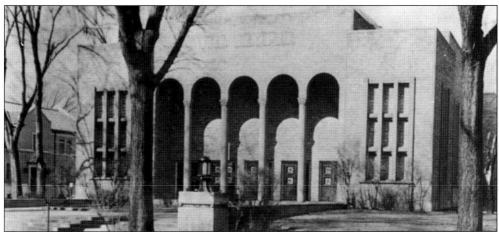

COLLINGWOOD AVENUE TEMPLE, 2335 COLLINGWOOD AVENUE, BUILT IN 1916. The Collingwood Temple, dedicated February 1917, was starkly modern for that era in its lack of a cornice and the modernistic window designs flanking the Islamic-inspired arched entrance porch. The capitals of the columns supporting the arches were designed with geometric shapes instead of traditional classical idioms. Joseph S. Kornfeld, Rabbi from 1924 until 1934, is believed to have been the first Rabbi to head a U.S. mission abroad when he was appointed by President Harding as minister to Persia in the early 1920s. The congregation moved to a new synagogue on Sylvania Avenue in 1973.

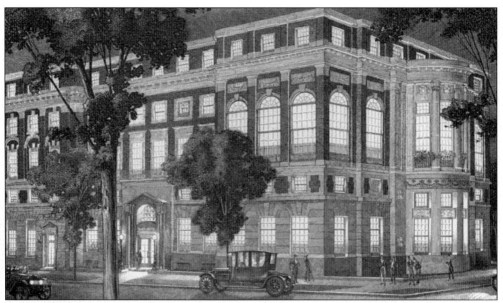

THE TOLEDO CLUB, MADISON AVENUE AND FOURTEENTH STREET, BUILT IN 1915. The Toledo Club, founded in 1889, moved from its Romanesque revival club house at Madison and Huron Street to this elegant neoclassical structure in what was still primarily a residential neighborhood, though the new Central Post Office had been constructed across the street only a few years earlier. Architect George Mills toured a number of clubs in the East with members of the board of directors for inspiration. The final design bears a certain resemblance to the newly completed Knickerbocker Club in New York City by architects Delano and Aldrich.

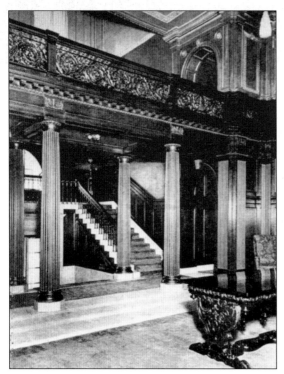

The Toledo Club building is warm red brick with stone accents in the English Georgian revival style. The Main Dining room on the third floor to the right has a large bow window and floor to ceiling windows. The club also contains two large reception rooms, two bars, a ballroom, and private dining and card rooms. Service areas and hotel rooms at the attic level are revealed by smaller square windows. An athletic wing was added in 1925.

THE TOLEDO CLUB LOBBY. Except for a few Toledo churches and the Peristyle at the Museum, the Club's interiors are among the few Toledo interiors little changed from the time of their construction. The lobby resembles the entrance hall of an English country house with oak paneling and columns and stenciled decoration on the ceiling an impressive chandelier. The torcheres on the stair landing with their marble turtle bases still stand in their original location.

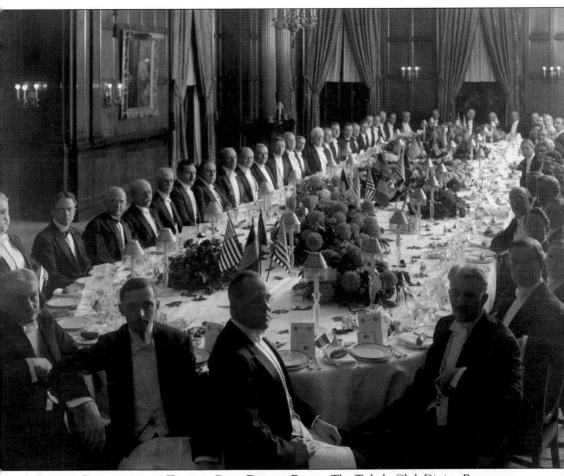

A FORMAL DINNER IN THE TOLEDO CLUB DINING ROOM. The Toledo Club Dining Room was the last place in Toledo to require men to wear a coat and tie, a rule relaxed only recently.

This photo is thought to depict a dinner held by John North Willys on September 7, 1919 f and the most prominent men in Toledo are here. Edward Drummond Libbey sits at the center of the table on the left side and Museum Director George Stevens is five heads down on Libbey's right.

Brand Whitlock, possibly the man leaning forward at the right about half way down the table was a popular four-term mayor. He stood for everything Toledo's beloved mayor, Golden Rule Jones, had stood for with little interest in vice issues such as prostitution and drinking. He believed that criminals were the product of bad circumstances, and was known as "The Great Suspender" for all the suspended sentences he gave out. Whitlock had little interest in the common folk as related by *Blade* editor Grove Patterson, "On one occasion—and there were many—as our city hall reporter related it, a group from the longshoremen's union was clustered hopefully around the mayor's door. Whitlock, as was his custom, received them in his aloofly cordial manner, shook hands with each man, and listened with an inwardly supercilious but outwardly benign patience to their woes. In the good Golden Rule Jones manner, he promised that everything should be sweet and the city docks would soon be abloom with roses. The delegation departed in smiles, with the next election ballots practically already marked, whereupon the mayor retired to his rest room, washed his hands carefully with serviceable soap, muttering to our reporter, 'goddam such a nuisance.' "

Whitlock was named Minister to Belgium in 1913 and stayed after the 1914 German invasion to help feed Belgium citizens. He wrote 18 books and died in France in 1934.

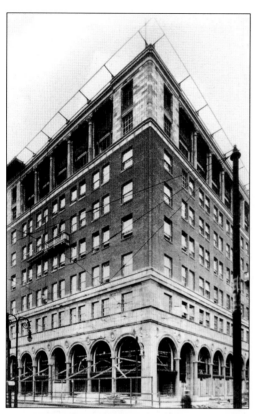

THE LASALLE AND KOCH DEPARTMENT STORE, 513 ADAMS STREET AND HURON STREET, BUILT IN 1917. Jacob LaSalle, a former captain in the Civil War, and his partner Joseph Epstein opened their first dry goods store in 1865, and they merged with the firm of Joseph Koch in 1880. The store moved from its old Jefferson Avenue location when their new store was completed in 1917, and 90,000 people showed up on opening day. The New York architectural firm of Starrett and Van Vleck designed a number of department stores such as the Saks Fifth Avenue, Lord and Taylor, and Abercrombie and Fitch stores in New York City. The first floor had polished granite columns supporting rows of arches with circular medallions above, and it is echoed by the two-story Corinthian-style colonnade on the top floors. The wide projecting cornice is just being installed to protect shoppers from the rain. Macy's managed the store since 1924, and later changed its name to Macy's. It closed in 1984. The building was purchased by the city in 1984 and sat empty for ten years until a developer converted it into one and two bedroom rental apartments. (PL.)

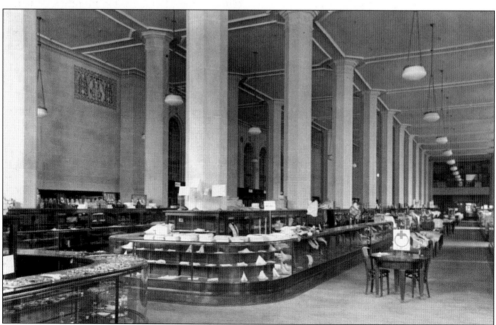

THE MAIN FLOOR OF LASALLE AND KOCH'S. The central aisle was one of Toledo's most traveled paths since it connected to the Spitzer Arcade, and one could walk indoors from Adams Street to Madison Avenue. (PL.)

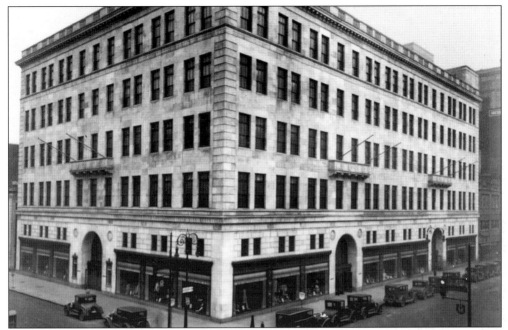

LAMSON'S DEPARTMENT STORE, 600 JEFFERSON AVENUE AND HURON STREET, BUILT IN 1928. Julius Lamson came to Toledo in 1873 and ran a dry goods store; he opened his own store in 1885; and by 1905, the Lamson Brothers Company had become one of the largest dry goods stores in the Midwest. In 1899, they purchased a battery powered delivery truck, which was thought to be the first horseless carriage ever seen on the streets of Toledo.

Considered Toledo's fanciest department store, Mills, Rhines, Bellman, and Nordhoff designed a Florentine renaissance-style palace with massive blocks of dressed stone on the lower floors and corners giving it a fortified appearance. The windows and the first floor display windows were practical modifications to the palace design. The store had three triumphal arch entrances decorated with emblems of Florentine arts and crafts guilds with balconies above.

The store closed in 1974 due to the popularity of suburban malls, and the building was converted to 1 Lake Erie Center in 1978, providing more than 100,000 square feet of office space.

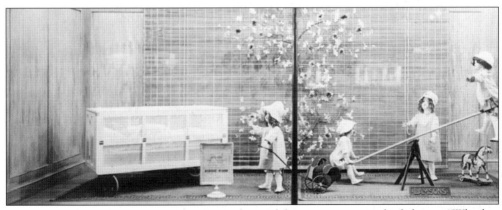

A LAMSON'S EASTER DISPLAY. The sign in front of the contraption to the left says, "Whether in or out doors Mother knows that Baby is safe from harm in a kiddie koop." It was said that the Lamsons were very devout and put black curtains over their window displays on the Sabbath. (Photo by Charles Byers, PL.)

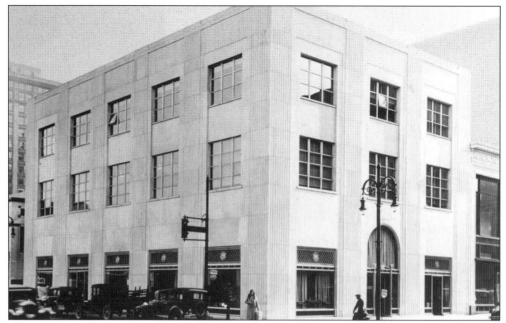

THE BROER FREEMAN JEWELRY STORE, 626 JEFFERSON AVENUE, BUILT IN 1929–1930. This Indiana limestone covered building with cast aluminum trim was designed by Mills, Rhines, Bellman, and Nordhoff for the Broer Freeman jewelry store. It was an elegant understated building, neoclassical in feeling, with fluted column-like decoration between the windows.

The store was founded in 1878, merging with another jeweler in 1914 and becoming Broer Freeman's at the time this store opened. The downtown store closed in 1983. (PL.)

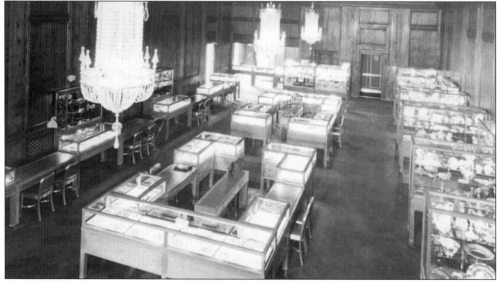

BROER FREEMAN'S, MAIN FLOOR. This was the jewelry and silver department, and "simplicity and beauty mark the interior furnishings and equipment of the new J.J. Freeman home." The furnishings were designed by the architects with aluminum chairs with blue leather upholstery matching the tabletops. The display cabinets were walnut, the walls were covered with knotty pine, and crystal chandeliers hung from the ceiling. (PL.)

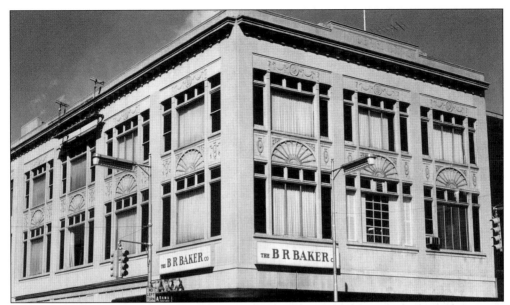

THE MINIGER BLDG, ADAMS STREET AND SUPERIOR STREET, BUILT IN 1927 AND DEMOLISHED IN 1980. The Miniger Building was a good example of the restrained formalism popular in architecture in the decade before the Depression. The decorative detailing above the second and third floor windows was strongly reminiscent of the work of 18th-century architect and decorator Robert Adam. The use of limestone further contributed to this sense of refined elegance. The building was long occupied by the B.R. Baker Company, Toledo's most popular men's and boy's clothing store until it closed in 1972.

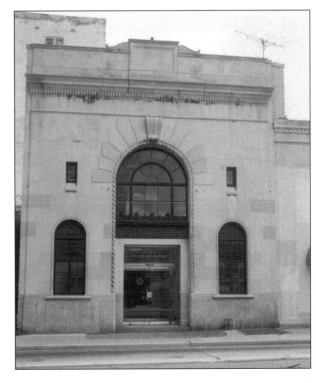

THE MORRIS PLAN BANK, 234 ERIE STREET, BUILT IN 1922. A wonderful small bank building, the design of which is nothing more than a large triumphal arch with a few windows added. (PL.)

59

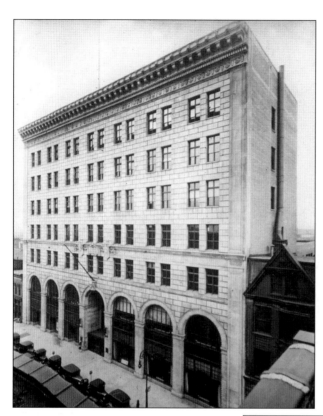

OHIO BELL TELEPHONE BUILDING, 121 HURON STREET, BUILT IN 1925. The building was constructed for the business offices of the phone company. The Ohio Bell Telephone Company was formed in 1921 and consolidated the Toledo phone system in 1924. The Bell phone operators received 4,155 calls a day in 1927. The building, designed by Mills, Rhines, Bellman, and Nordhoff had a massive arcade on the first floor with an elaborate cornice at the roofline.

THE HOME BANK BUILDING, 519 MADISON AVENUE AT HURON STREET, BUILT IN 1924. Cleveland architects Walker and Weeks formed a partnership in 1911 and quickly established a reputation as masters of neoclassical bank design. Their banks symbolized conservatism and stability, and they designed over 60 in Ohio, including Cleveland's Federal Reserve Bank. The Home Bank Building was designed in the Renaissance revival style with a shield of the City of Toledo carved above the entrance and lions heads on the parapet. The interior still contains its elaborately decorated banking room. (Photo by Zink, PL.)

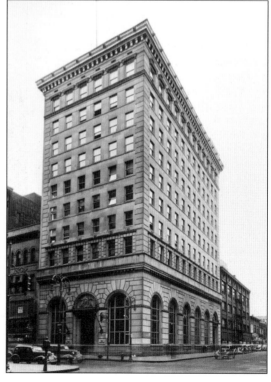

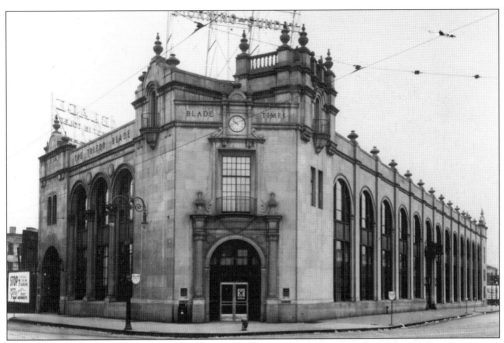

Toledo Blade Building, 541 Superior Street, Built in 1927. President Calvin Coolidge pressed a button from the White House to start the presses on May 2, 1927, when the *Blade*'s new building was officially opened. Babe Ruth made a personal appearance to promote the opening and played at Swayne Field. The building by architects Langdon, Hohly, and Grow was vaguely Spanish Renaissance in style with a series of arches and balconies, topped by numerous stone urns. Founded in 1835, the *Blade* was purchased in 1926 by Paul Block, a man who controlled or owned over a dozen newspapers between 1916 to 1941. Block was a close personal friend of press magnate William Randolph Hearst and was the executor of his will. Block was a frequent visitor to San Simeon and friend to such notables as George Gershwin, Will Rogers, and Fanny Brice. (Photo by Barton Herrick, PL.)

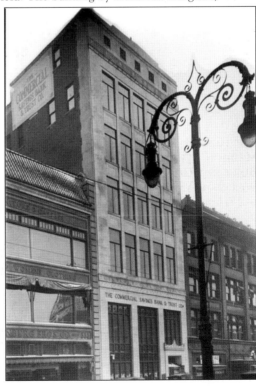

The Commercial Savings Bank and Trust, 335-37 Superior Street, Built in 1927. Bank architecture embraced the new "Moderne" style, which was a streamlined version of the neoclassical style with basically the same decorative forms but simplified and geometricized. The buildings had the same sense of symmetry with areas of sculptural embellishment and traditional uses for masonry. (PL.)

61

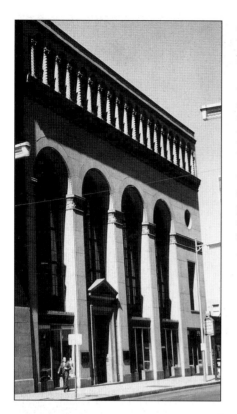

THE SECURITY BANK, 607 MADISON AVENUE, BUILT IN 1928–1929. The Security Bank was another neoclassical-inspired design for a financial institution, but made less conservative looking with the addition of Byzantine and modernistic elements. The structure was a good illustration of the quality and attention to detail, which typified the work of the architectural firm of Mills, Rhines, Bellman, and Nordhoff.

The façade was "modernized" in 1964 at the same time as the neighboring Nasby Building with the application of a veneer of blue and white panels. A promotional brochure said, "Panels of blue porcelain enamel will keep the building young looking and free of burdensome upkeep well past its centenary."

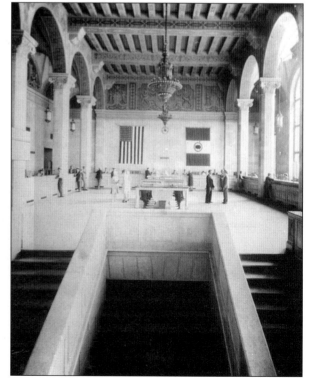

THE SECURITY BANK LOBBY. The huge banking room was especially noteworthy, with massive chandeliers, a decorated beamed ceiling, and a monumental marble staircase. The lobby was removed to provide more office space. The marble staircase is all that remains of the interior; it now leads up to a wall.

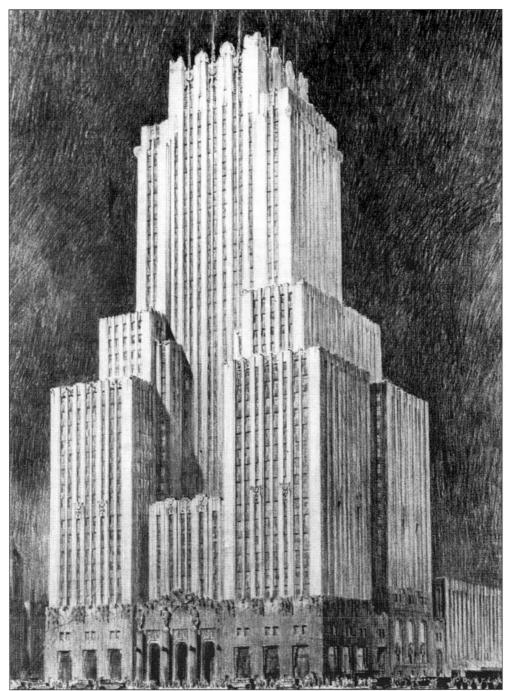

A PROPOSED TOLEDO OFFICE BUILDING. This 34-story office building was to be built by Toledo businessman C.O. Miniger on Madison Avenue between Erie Street and Ontario Street in 1928. It was to be constructed of limestone, a common building material that was self-cleaning when washed by rain. The building had a strong vertical emphasis and didn't rise straight up from the street line, but was set back on a series of vertical planes as it reached the top.

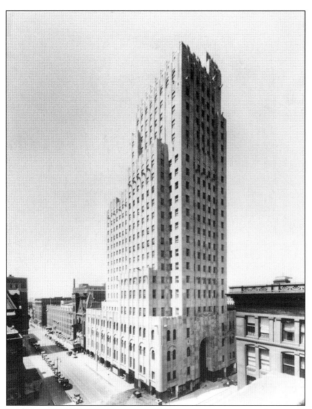

THE OHIO BUILDING, 405 MADISON AVENUE AT ST. CLAIR STREET, BUILT IN 1929–1930. The Ohio Building was the high point in the evolution of the skyscraper on Madison Avenue. It is such a fine design that one can hardly regret the demolition of the Boody House Hotel for its construction. Measuring 368-feet high and faced with limestone, its elegant streamlined "Moderne" design symbolized Toledo's enormous 1920s prosperity, which was soon to end. The design by architect John Richards of Mills, Rhines, Bellman, and Nordhoff was clearly inspired by Eliel Saarinen's unsuccessful 1922 entry in the Chicago Tribune competition and possibly by New York's Rockefeller Center. The most popular skyscraper form by the 1920s was a vertical tower with setbacks decorated with geometric ornament. The Ohio Building had these features plus projecting gargoyles and figures over the monumental arched entrance depicting Mercury with his Cadeusis and Progress with a rubber automobile tire. During construction by the Bentley Company, a piece of limestone being hoisted up the side of the building broke loose and in its fall sliced through the roof and floor of a parked Model T, broke through the street and into a vault below, slicing into electrical cables. (PL.)

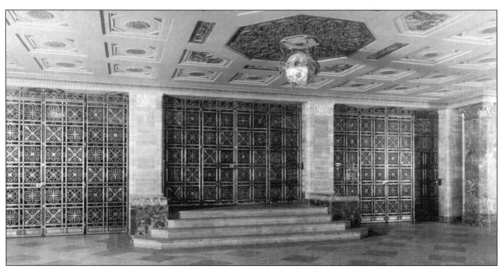

THE ENTRANCE LOBBY. When the gates were open, one could go up a flight of stairs to the banking lobby. (PL.)

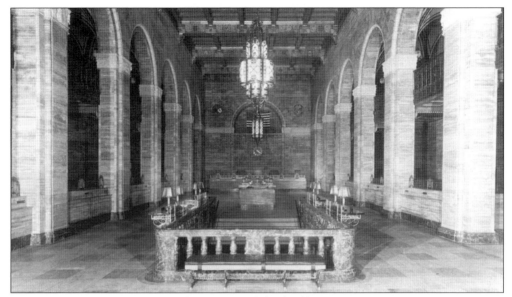

THE OHIO BUILDING LOBBY. The interior of the building was as impressive as its exterior, especially the majestic banking lobby. The lobby was inspired by 13th-century Florentine church designs, with a massive beamed ceiling and vaulted side aisles. Here the side aisles have been employed for the teller's spaces, with balconies on the second floor. The lobby displayed a wealth of marble and bronze decoration, and all of the decorative elements, even down to lamps and wastebaskets, were styled to harmonize with the overall decorative scheme.

Constructed by the Ohio Savings Bank and Trust, the bank occupied the building for less than a year before it was forced to close in August 1931 due to the Depression. The building was purchased in 1935 by the Owens-Illinois Glass Company, and the "OI" sign at the top of the building was installed in 1955. The lobby was destroyed in the 1960s to provide additional office space, thus losing one of Toledo's most exciting interior spaces.

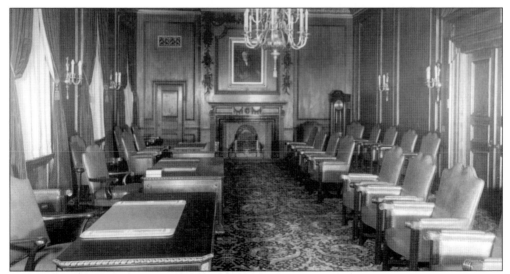

THE EXECUTIVE FLOOR. The executive offices were more traditional with English Georgian-style paneling and fine woodcarvings of foliage above the fireplace. The portrait over the fireplace was of bank president David Robison, Jr. (All photos by Hauce, PL.)

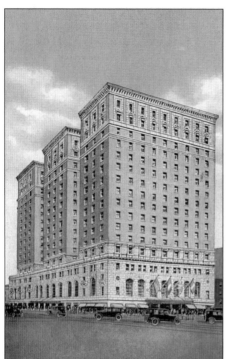

THE COMMODORE PERRY HOTEL, 505 JEFFERSON AVENUE, BUILT IN 1927. The hotel was built by Toledo businessmen George Jones and Willard Webb and named for the hero of the Battle of Lake Erie in the War of 1812. Mills, Rhines, Bellman, and Nordoff may have been influenced by the design of the Hotel Pennsylvania in New York City or the Statler Hotel in Buffalo. Like the 1908 Hotel Secor across the street, the Commodore Perry followed the same classical vocabulary, but it has become simplified and more streamlined, revealing the growing influences of modern architecture.

The hotel was built on a four story stone base housing the public rooms, and separate towers above to provide light and air to all of the guest rooms. Even though it figured prominently in advertising photos, the rear third tower was never built. The hotel had over 500 rooms with 500 baths and cost $4 million to build. At the time of its completion, it was considered the largest hotel between Chicago and Cleveland.

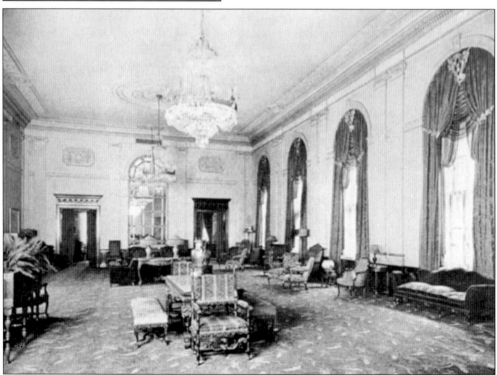

THE MAIN LOUNGE. The room was graced with crystal chandeliers and heavily carved furniture. The hotel was sold to a Brooklyn, New York-based hotel chain in 1934, and some of the public spaces were remodeled, and air conditioning was installed.

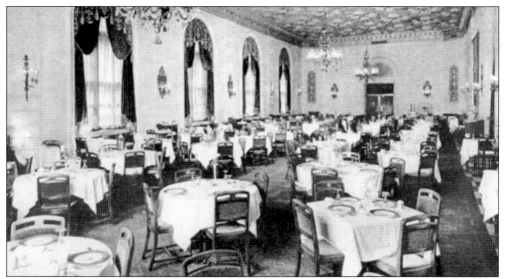

THE TRAVERTINE DINING ROOM. The bellboys were inspected at the start of each shift for clean hands, fingernails, shined shoes, and proper haircuts. Elvis Presley got into a fight at the Commodore Perry in 1956. A man came up to him and said, "My wife carries your picture but doesn't carry mine!" The ensuing fistfight was later revealed to be a publicity stunt. Other guests included Harry Truman, Jack Dempsey, and Jimmy Stewart. Bob Hope's son's wedding reception was held here.

Victor Giles ran the hotel in 1970s; he was a flamboyant Irishman, The *Blade* wrote a "veteran huckster and shameless promoter," and it was said that "He kissed all the ladies, flattered all the men, and spread a thick layer of blarney all around with his rich Irish brogue."

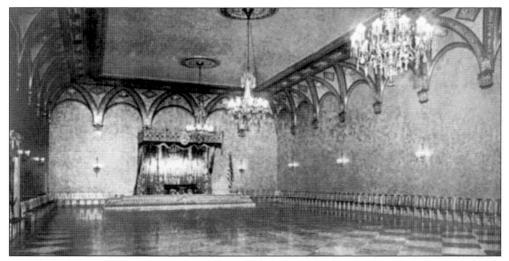

THE COMMODORE PERRY BALLROOM. The ballroom had a distinctly Spanish feel; it had murals painted by William F. Matthews, and one could imagine Spanish royalty sitting on thrones under the canopy at the back of the room.

After 53 years of operation, the hotel closed in 1980, and the last commercial tenant left in 1985. There was some discussion about reopening it as a hotel, but there were fears that it would compete with the new hotels recently constructed downtown. The building has recently been converted into apartments.

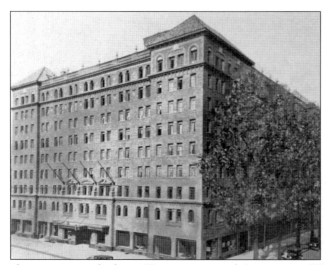

THE HILLCREST ARMS APARTMENT HOTEL, MADISON AVENUE AT SIXTEENTH STREET, BUILT IN 1929. Toledo architects Hahn and Hayes designed this $2 million residential hotel for C.O. Miniger in what was described as "modern Romanesque architecture." It had 245 one, two, and three room apartments with a roof garden and a 150-car garage. During a visit to Toledo to give a lecture in 1933, Amelia Earhart painted an arrow on the hotel's roof pointing to closest airport, which was Transcontinental Airport near Walbridge, Ohio, now known as Metcalf Field. She said, "It would be a pretty poor sort of an aviator who wouldn't know he was over Toledo, (but) what fliers need most urgently is better marking of small towns."

The Hillcrest became a conventional hotel during World War II. The hotel closed in 1990, had a fire in 1994, and it was almost demolished for a parking lot, but was instead renovated for apartments

THE PARK LANE HOTEL, JEFFERSON AVENUE AND TWENTY-THIRD STREET, BUILT IN 1925. The Park Lane's motto was "the best home address in Toledo," and it was a favorite residential hotel for wealthy widows giving up their Old West End homes: "The Park Lane affords every refinement and convenience that a perfectly appointed hotel can devise, yet it retains the delightful atmosphere of a cozy comfortable home." The hotel had 187 rooms in 114 units, with maid and valet services, and a ballroom, which could easily accommodate 200 people. Designed by Mills, Rhines, Bellman, and Nordhoff, it conveyed a certain sophisticated, old money elegance with its warm red brick and refined neoclassical detailing. The hotel was purchased by Sam Davis in 1948, and the lower floors were remodeled in a modified colonial motif. In 1953, the hotel became half transient, and celebrities such as Marilyn Monroe, Bob Hope, Sonya Heine, Jennette MacDonald, and Pat Lawford stayed there when they were in town. The hotel closed abruptly in 1970, much to the surprise of many because it was still a fashionable destination, and the closure seriously demoralized the neighborhood. It stood empty for over 20 years until it was renovated as apartments for the elderly. (PL.)

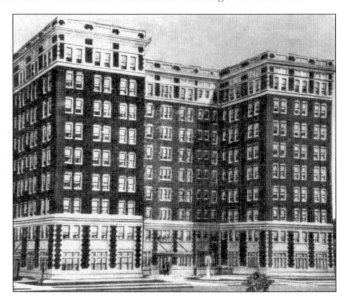

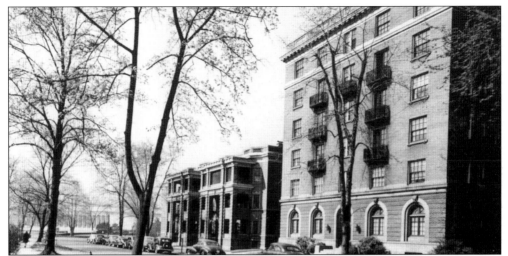

THE PLAZA HOTEL AND APARTMENTS, MONROE STREET AT SCOTTWOOD AVENUE, BUILT IN 1903, 1916–1917, AND 1931. This complex of buildings was originally opened in 1903 as the Scottwood Apartments. It was renamed the Plaza in the 1920s after more buildings were constructed, and the owners wanted a fancier sounding name since it was located directly across the street from the Toledo Museum of Art.

After the building became run-down in the 1970s, it was offered unsuccessfully to the museum and later to the city. Renovations began after it was purchased by a firm planning to turn the buildings into apartments for the elderly and handicapped.

The 1903 building to the left was destroyed after it was firebombed in 1979. The project was finally completed in 1983. (Photo by Zink, PL.)

FLORENCE CROSBY WALDING IN HER LIVING ROOM. Miss Walding moved from her family home on Collingwood Avenue after the death of her mother to an apartment in the Lincoln at 2330 Monroe Street. Even though the furniture probably all came from her parents' home, the interiors here were much different. There are few pictures on the walls, the window treatments are simple, and the surfaces are generally uncluttered. She sits knitting, surrounded by the necessities of life. The radio is behind her in the bookcase, and on the side table she has her cigarettes, telephone, and maid's bell. Long in delicate health, Florence Crosby Walding died in the mid 1950s.

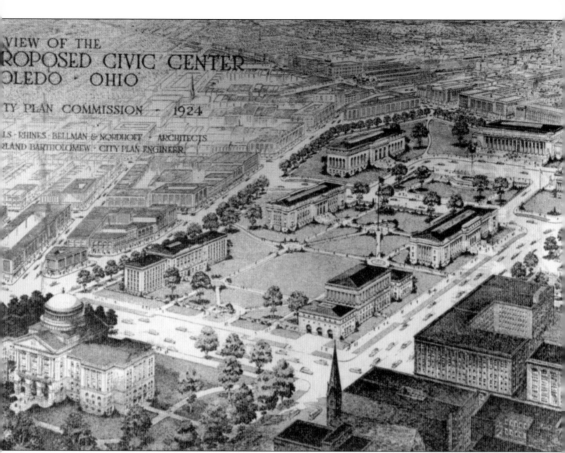

VIEW OF THE
ROPOSED CIVIC CENTER
OLEDO · OHIO

TY PLAN COMMISSION · 1924

LS · RHINES · BELLMAN & NORDHOFF · ARCHITECTS
RLAND BARTHOLOMEW · CITY PLAN ENGINEER

A VIEW OF THE PROPOSED CIVIC CENTER, c. 1924. In 1916, the City Planning Commission recommended that land be acquired in a quadrangle bounded by Spielbusch, Jackson, Erie, and Cherry Streets for a civic center. The plan would include new buildings housing county and federal offices with a new municipal auditorium facing the old courthouse at the opposite end. To the left of the old Courthouse, a county office building was planned to alleviate the overcrowding at the Courthouse by transferring all county administrative offices there and to include a jail on the top two floors to replace the old one. The city hall that Toledo never had was planned to the right of the Safety Building. The municipal auditorium resembled Butler Library at Columbia University in New York City—actually the entire plan somewhat resembled the Columbia University Campus. Of all the planned buildings, only the Safety, Federal Court, and Police and Fire Alarm Building were actually built. Municipal Building and County Administration Building designs were proposed again in the late 1930s, but were still not built. (PL.)

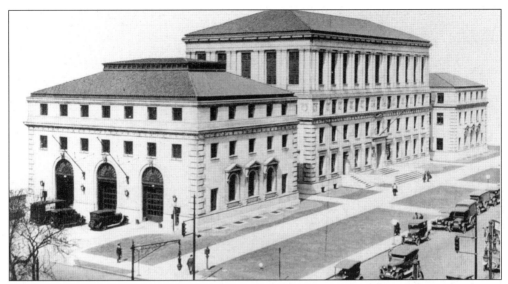

THE SAFETY BUILDING, 525 NORTH ERIE STREET, BUILT IN 1929. The neoclassical style was the only style for government buildings during the early decades of the 20th century. The Safety Building, designed by Mills, Rhines, Bellman, and Nordhoff is an elegant stone structure flanked by wings with fine proportions and sharp neoclassical detailing. The decorative ironwork over the Jackson Street entrances is particularly fine, and the sculpted stone faces above have traditionally been said to symbolically depict the women of Toledo. The building inadvertently became Toledo's City Hall until 1982, sharing offices with the police division. (PL.)

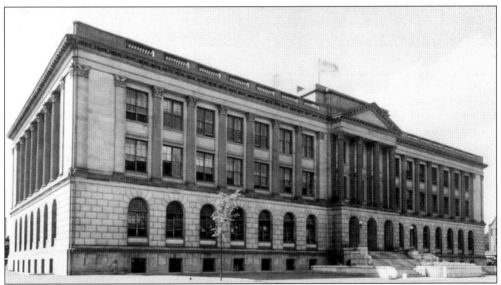

U.S. COURT AND CUSTOM HOUSE, 1716 SPIELBUSCH AVENUE, BUILT IN 1929–1931. This traditional design would be right at home in the bureaucratic architecture of Washington D.C. Designed by Graham H. Woolfall, a U.S. Treasury Department architect, it has a fine two-story Corinthian colonnade above an arcaded basement, suggesting fortified walls. The structure was built for Federal offices to replace the overcrowded offices in the old Federal Building and Post Office at Madison Avenue and St. Clair Street. After a new Federal Building was constructed in 1962, only offices for United States Customs and Courts remained. (PL.)

FIRE STATION NO. 21, GLENDALE AVENUE AND DETROIT AVENUE, BUILT IN 1929–1931.
This suburban fire house exhibits many stylistic elements of the English gothic style found in many schools and houses of the era. Designed by architects Bollinger and Hayes, it is constructed of warm, red brick with stone trim. The pointed window gables on the second floor give it a slightly whimsical feeling. A planned medieval style half-timbered hose-drying tower was never constructed. (Firefighters Museum.)

FIRE STATION NO. 1, 701 BUSH STREET AND ERIE STREET, BUILT IN 1927. This is considered to be one of famed Toledo architect David Stine's final commissions. Stine employed Spanish or Mediterranean influences with a red tile roof, stucco walls, iron balconies, and a domed hose-drying tower. Except for the front doors, the building could be mistaken for a Spanish church and the hose-drying tower could be mistaken for a bell tower. (Firefighters Museum.)

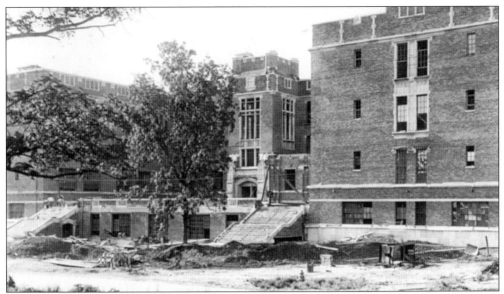

MCKINLEY SCHOOL, 1901 WEST CENTRAL AVENUE, BUILT 1923–1924. In 1920, voters approved an $11 million bond issue, and ambitious expansion projects were planned, including construction of most of Toledo's elementary schools. McKinley resembled many other schools built at the same time; it was designed by Edwin Gee in a collegiate gothic style built on a raised basement to provide additional classroom space. The Depression caused great troubles for the city schools, and many of their funds were frozen in closed banks. In 1931, the school year was reduced to nine months from ten, and consideration was given to ousting all female teachers who had husbands who were employed, but this wasn't carried out. In 1939, the lack of funds during winter months caused schools to shut down for six weeks. (Photo by Korb, PL.)

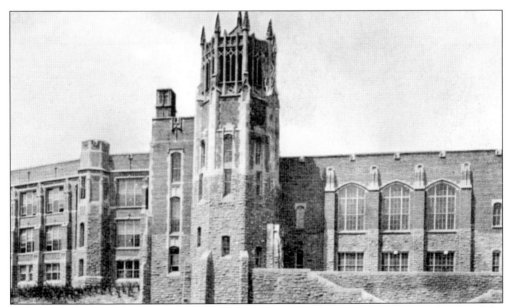

HARVARD SCHOOL, 1949 GLENDALE AVENUE, BUILT IN 1926. Built along the banks of the Maumee River in South Toledo, Harvard School was one of the most picturesque of all Toledo schools, constructed of a mixture of stone and brick with a beautiful openwork tower. (PL.)

THE WEST TOLEDO BRANCH LIBRARY, 1320 SYLVANIA AVENUE, BUILT 1929–1930. This branch library was built in a middle class neighborhood of young married couples with children. Architects Gerow and Conklin designed a small English manor house with a large leaded glass window and gables in an irregular rambling shape. The library had rented quarters nearby since 1923, and this building opened in 1930, with a collection of 20,235 books and a first year circulation of 192,702. (PL.)

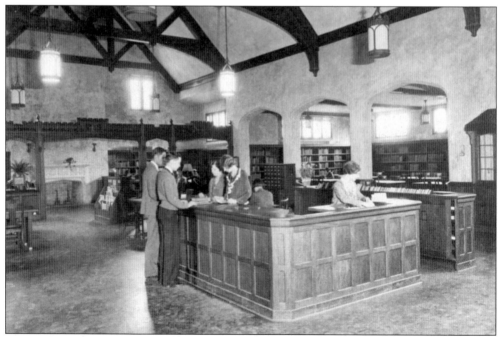

THE LIBRARY CIRCULATION DESK. The interior exhibited a hammer-beam roof hung with lanterns, lots of gothic arches, cozy window seats, and an interesting carved wooden screen creating a separate alcove by the large fireplace. (PL.)

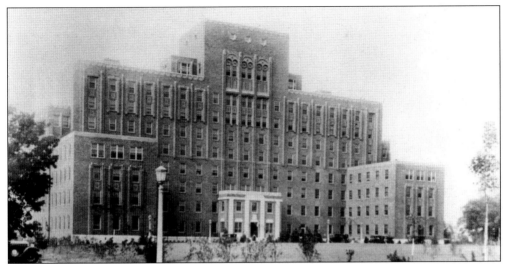

TOLEDO HOSPITAL, 2142 NORTH COVE BOULEVARD, BUILT 1927–1929. The new Toledo Hospital was many times the size of the old 1892 Cherry Street building. Located in expanding West Toledo on a 22-acre site facing Ottawa Park, the new hospital had 250 beds with a nurses home for 150 nurses. Designed by Schmidt, Gordan, and Erickson of Chicago, the original massive eight-story structure has four-story wings like arms reaching out to welcome or reassure the patient. Vertical brick detailing helps to reduce the impact of the buildings size. Major additions were made in 1954, adding 180 beds. Into the cornerstone of this addition were placed the four miracle drug discoveries of the day—radioactive iodine, a vial of penicillin, a preparation of cortisone, and the polio vaccine. This building will be demolished in the next few years, a casualty in the recent orgy of demolition and expansion of health care facilities everywhere. The large star atop the building at Christmastime has long been a West Toledo landmark.

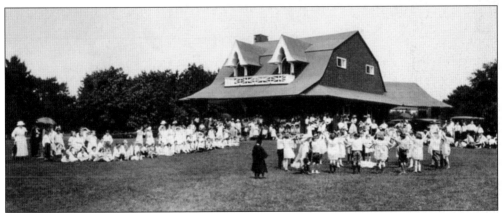

A VIEW OF THE OTTAWA PARK PAVILION. This photo taken in about 1920 shows the children from Monroe School enjoying a class outing by the 1903 park pavilion. When these 280 acres were purchased at the edge of the city in 1892, it created a storm of protest and criticism that no one would ever visit it. Park commissioner and City Welfare director Sylvanus P. Jermain designed the first municipal golf course in America west of New York here in 1899 and expanded the original nine holes to eighteen in the early 1920s. Jermain, called the "Father of Public Park Golf in America," is credited with establishing more than a dozen parks, eight playgrounds, half a dozen swimming pools, and three municipal golf courses: Ottawa Park, Bay View Park, and Collins Park. (PL.)

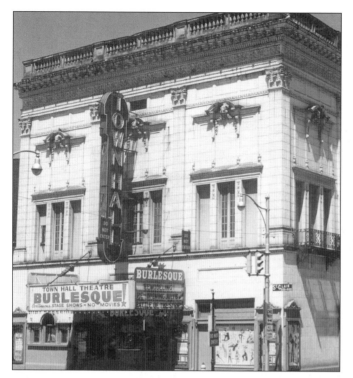

THE TOWN HALL THEATER, ST. CLAIR STREET AND ORANGE STREET, BUILT C. 1887 AND DEMOLISHED IN 1968. Originally known as the New People's Theater and later known as the Lyceum, it presented musicals, dramas, and stock companies. In 1919, the theater was renamed the New Empire and offered burlesque entertainment. Danny Thomas got a job there as a young boy one winter: "We decided to seek part-time employment inside, where it was warm. That's how I got into show business for the first time. Hired to sell soda pop and candy in the theater's balcony. . . . It was fascinating to me just to be inside a theater every day. This was the 1920s, and the entertainment world was in a golden era even in a small city like Toledo." The façade was remodeled with neoclassical style glazed terra cotta in the 1920s. The theater was renamed the Town Hall in 1945 and for the next dozen years presented legitimate stage productions.

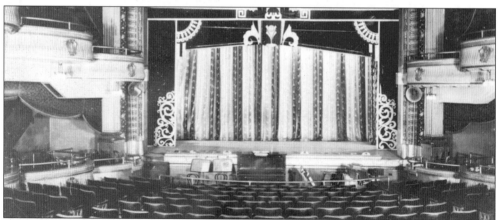

THE INTERIOR OF THE TOWN HALL THEATER. In 1958, the theater was purchased by Rose La Rose, one of America's legendary strippers, and under her ownership burlesque was revived. Rose once said, "Burlesque is more than girls stripping. It is beautiful costumes, comics, production numbers, and much more." *Blade* reporter Seymour Rothman wrote, "she ran her theater like a meticulous housewife. One of her first acts after giving the place a thorough redecorating and cleaning was to do it all again. She wanted it as spotless as the old building could be made."

Rose La Rose moved to the Esquire Theater on Superior Street when the old theater was razed as part of the Vistula Meadows Urban Renewal Project. (PL.)

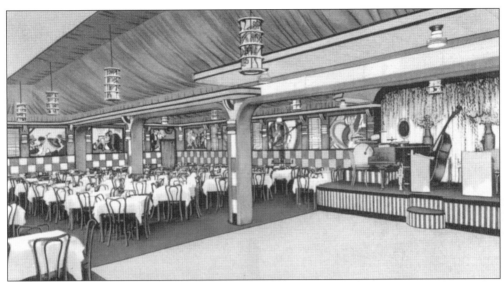

THE KIN WA LOW, 814-16 JEFFERSON AVENUE. Toledo had a number of popular supper clubs: Ka-sees, the Bon-ton, the Crescent Club, The Dells, and the Trianon Ballroom. The Kin Wa Low, meaning "lovely flowering palace," was one of the most popular of these clubs, especially on prom night. For a 50¢ cover charge one could be entertained by a wide assortment of performers, and for $1.50 they could see big-name acts like Ella Fitzgerald. The club closed in 1962.

THE RIVOLI THEATER, 430 ST. CLAIR STREET, BUILT IN 1920 AND DEMOLISHED IN 1969. The Rivoli opened in 1920 as both a vaudeville and a movie theater. This area of downtown Toledo in the vicinity of St. Clair and Adams had the largest concentration of theaters in the city. Big names such as Bob Hope, Blackstone the Magician, Mae West, and Pavlova all appeared at the Rivoli. After vaudeville faded and big stars no longer traveled on the road, the Rivoli became exclusively a movie theater. The theater and its neighbor, the Palace, were both victims of Toledo's urban renewal program. (PL.)

JOE E. BROWN WITH UNIDENTIFIED COSTAR. Actor and former Toledoan, Joe E. Brown, is not a recognizable face today, but back in the 1930s he was among the top ten box office stars for three years running, and he is best remembered today as Jack Lemmon's ardent suitor in *Some Like It Hot*. He wrote about his poor childhood, "Living near the railroad had its advantages. I could always find a few pieces of coal along the tracks. One day I discovered a way to increase my 'take' and learned for the first time how to use my face to an advantage. I made faces at the trainmen, and they'd throw coal at me—sometimes enough to feed our stove for days. I did pretty well at it, and sometimes they threw coal when I wasn't making faces. They only thought I was."

THE PANTHEON THEATER, 325 NORTH ST. CLAIR STREET, BUILT IN 1919 AND DEMOLISHED IN 1999. The historic Charles Messinger house originally stood on this site and later a popular German restaurant called the Kaiserhof. The new Pantheon Theater could seat 1,000 with all the seating on one floor with no balconies. The interior was gray and peacock, and "the drop curtain carries a Garden of the Palace and pergola scenes adorn the sides." The opening movie shown at the Pantheon was "Broken Blossoms" with the Gish sisters. After World War II, it hosted the Roy Rogers Club on Saturdays with movies and special acts and a registration list of over 15,000 children. The Pantheon was the last movie theater in the downtown area when it closed in 1977. It was demolished for yet another parking garage. (PL.)

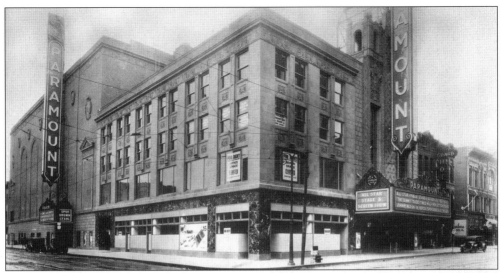

THE PARAMOUNT THEATER, 518-20 ADAMS AND HURON STREET, BUILT IN 1929 AND DEMOLISHED IN 1965. The structure was designed by Rapp and Rapp of Chicago, America's top theater architects, and completed in 1929 at the cost of $3 million. It was the largest and most elaborate theater in Toledo—a "Movie Palace" in every sense of the word. "The fairyland of entertainment for Toledo will have every detail of comfort and pleasure for patrons in addition to the beauties for eye and ear." This early view of the exterior shows its two enormous signs, and none of the commercial spaces on the corner have yet been rented.

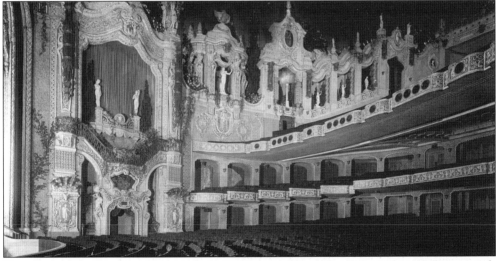

THE AUDITORIUM OF THE PARAMOUNT. The theater opened on February 16, 1929 to crowds of adoring movie goers. The *Blade* wrote, "A trip into a garden of dreams was the reward of a large crowd of Toledoans who stood in a long line to await admittance to the new Toledo Paramount Theater." The interior was a mixture of primarily Spanish and Moorish decoration with a dash of the baroque. The auditorium was designed in the "atmospheric" style, which created the impression that the theater was open to the sky, with painted clouds moving across the heavens and lights that twinkled like stars. Toledo had six first run movie houses, and the 25¢ price of admission was high compared with 10¢ charged elsewhere, but only the Paramount had its own chorus line, house orchestra, and $55,000 Wurlitzer concert organ.

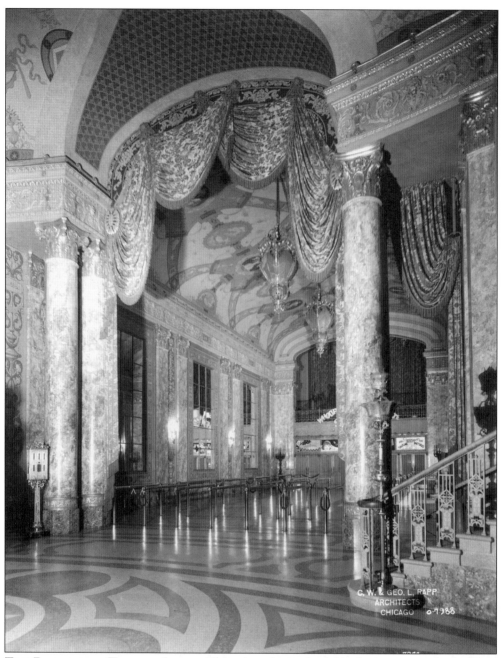

THE PARAMOUNT THEATER LOBBY. This view shows the lobby looking towards the front entrance, and one can see the beautiful terrazzo floor and one of the velvet covered railings of the twin staircases. The lavish use of marble, rare woods, murals, mirrors, brocaded tapestries, and gilded plaster relief paid homage to European Court Theaters and Roman palaces. Even if the movie was a turkey, it was still worth the price of admission to marvel at these interior spaces and transform yourself from your humdrum everyday existence. If any lost Toledo building could be magically recreated, it would certainly be the popular choice.

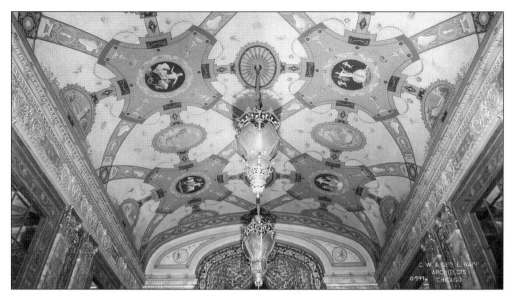

THE LOBBY CEILING OF THE PARAMOUNT THEATER. The ceiling was decorated with paintings by Julio and Giovanna Udine done in the Pompeian manner. "Up to the time of the first curtain Saturday, workmen swarmed over the theater racing with time to complete decorations and stage settings." One Toledoan reminisced. "My uncle worked at the Paramount Theater as a painter, and he got paid in $100 bills—no one in my family had ever seen $100 bills. My family was very poor at the time so my uncle and aunt bought each of their nieces and nephews a brand new sweater—it was one of the most memorable Christmas's of my life."

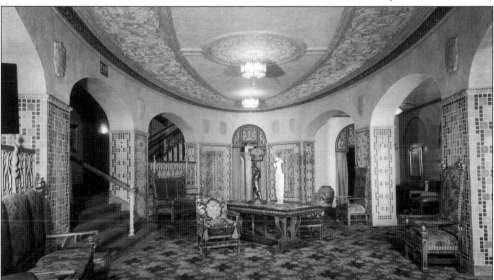

THE MEN'S LOUNGE. The oval lounge had wonderful decorative tile work and Spanish renaissance style furniture. Sculptures and paintings were used extensively, elevating the theater to an art gallery. Theater owners were among the most enthusiastic bidders at the auctions of the contents of gilded age mansions, buying furniture and sculpture and even entire rooms to properly furnish their new theaters. An old creek running under the building was used to the movie goers advantage by setting up fans in the cellar pushing cool air up to the public spaces and reputed to be the first use of air conditioning in a Toledo public building.

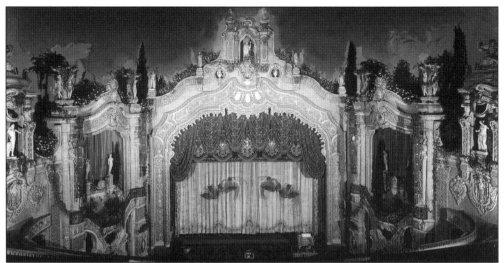

THE PARAMOUNT THEATER STAGE. Rapp and Rapp were known as the "Potentates of Plaster." The auditorium has been specially decorated in this photo with greenery for its opening. At the right side of the stage is the mighty Wurlitzer organ. One usually heard the organ before one saw it, as it rose up to the stage from the orchestra pit as the organist played away. The Wurlitzer was sold for $5,000 in 1965. In 1985, it was sold to a theater in Berkley, California leaving Toledo forever. (All photos courtesy of the Theater Historical Society of America.)

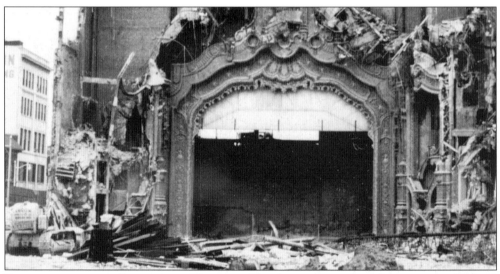

DEMOLITION OF THE PARAMOUNT THEATER. The theater was never a big money maker, and while acts such as the Marx Brothers, Mario Lanza, The Three Stooges, and Tom Mix ("We built a stall for Tom's horse, Tony, in the dining room of the Secor Hotel") were often sell-outs, there were just too many seats to fill the rest of the time. Entertainment tastes change rapidly, from the mid 19th-century lecture hall to the opera house, to vaudeville, to movies and then to TV. During the 1950s, it became impossible for the Paramount to compete with television. The management even went so far as to install a television in the downstairs lobby so patrons didn't have to miss their favorite programs. Viewed as a costly "white elephant" by its owners, the theater was razed in 1965, in the words of the *Blade* (where there were visions of employee parking spaces dancing in their heads), "for a modern attractive parking lot." (PL.)

Four
PERFECT SETTINGS FOR MODERN HOMES

A BILLBOARD FOR THE WELLES-BOWEN COMPANY IN 1929. The prosperity of the 1920s enabled the middle classes and the wealthy to move from the inner city to larger houses and lots in the newly platted neighborhoods of West Toledo. The Welles Bowen Company developed many of these areas as their sign says, and most of them were first laid out during and after World War I. The sign was located on Central Avenue at the edge of Old Orchard with a representative English cottage-style house pictured.

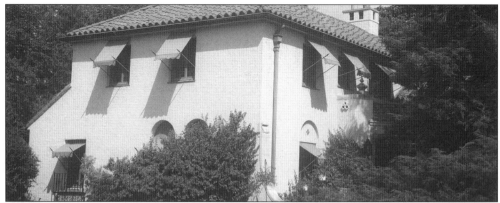

THE LINT HOUSE, 2104 RICHMOND ROAD, BUILT IN 1927. In 1916, the Welles Bowen Company put 323 lots up for sale in their new 90-acre development of Westmoreland. Bordered by Bancroft, Oakwood, Parkside, and Upton Avenue, it was named for Westmoreland County in eastern Virginia where George Washington was born, and the street names all have Virginia or Washington connections. The developers envisioned the "harmonious and artistic development of Westmoreland as a high grade residential subdivision," so there were restrictions on such things as lot size and single family dwellings; they had to have cellars, they couldn't cost less than $45,000, and no modern architecture was allowed. There were also restrictions prohibiting stables, cattle yards, hog pens, chickens, privies, advertising signs, or dumps. By 1930, over 100 homes had been built.

Amos Lint built this Spanish style house with such characteristic features as a tile roof, stucco walls, and a courtyard. He was president of the City Machine and Tool Company and an investor in the Welles Bowen Company.

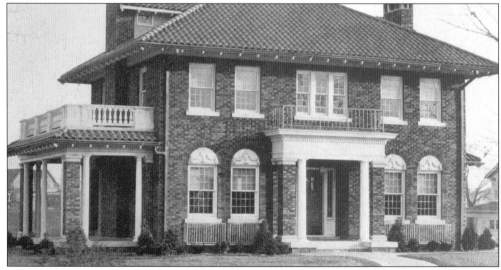

THE BRESNAHAN HOUSE, 2150 RICHMOND ROAD, BUILT IN 1925. The Carl Mehring Company built this brick house with neoclassical decorative detailing and a somewhat incongruous tile roof. This was the home of sports hero Roger Bresnahan. He had a 35-year career in baseball, playing for major league teams in Chicago, Baltimore, New York, and St. Louis. He was a player/manager for the Cardinals and the Cubs and played in the 1905 World's Series. Bresnahan later managed the New York Giants and the Detroit Tigers, and in 1916, he purchased the Mud Hens and managed them until 1924. He is credited with introducing shin guards to baseball.

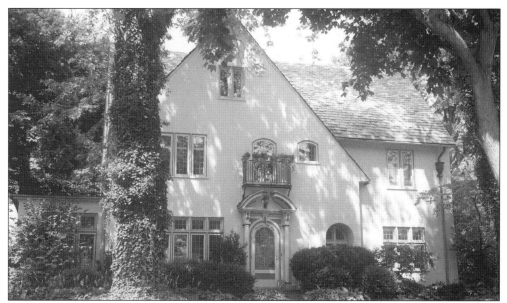

THE DONOVAN HOUSE, 1959 RICHMOND ROAD, BUILT IN 1925. David Stine designed this house for William F. Donovan, the former superintendent of the Cutting Department at the Libbey Glass Company, as a wedding present for his daughter Laura. Situated on a hill this romantic looking asymmetrical stucco-covered house has leaded glass windows and a beautiful neoclassical doorway with Tuscan columns supporting a round broken pediment.

THE CHAPMAN HOUSE, 2035 MT. VERNON ROAD, BUILT C. 1920. Attorney Charles Chapman owned this house, and one is tempted to suppose that this is he and his wife Elizabeth standing by their car with their chauffeur sitting in the back seat. This is one of the earlier houses built in Westmoreland, and it displays interesting geometric style roof brackets and a recessed entrance porch framed by columns.

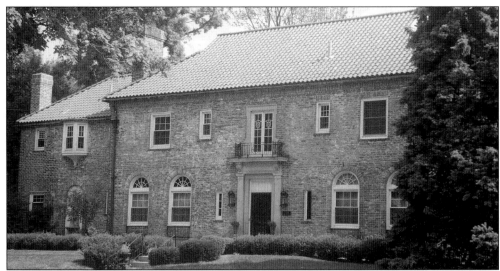

THE BOWEN-GIPE HOUSE, 2048 RICHMOND ROAD, BUILT IN 1923. Both Welles and Bowen built their homes in Westmoreland, and this is Badger Bowen's Italianate-style home designed by architect Leonard Geroe. The brickwork is very fine, especially the lovely salmon color and the bricks may have been salvaged from a demolished building. Badger Bowen was a strong advocate of city planning, having developed so much of residential West Toledo. He was a personal friend of Franklin Delano Roosevelt who was said to have visited the home when he was governor of New York. Though contrary to urban legend, Bowen did not install an elevator in the house to accommodate his wheelchair. Bowen died in 1931 during the worst days of the Depression and the same year that the Welles-Bowen Company moved out of its fancy building on Erie Street to a basement office in the Spitzer Building.

JOAN CHRITTENDEN GIPE'S WEDDING PHOTOGRAPH. A later owner of the house was John Gipe, plant manager at the LOF plate glass factory. Daughter Joan stands on front of the stone mantelpiece purchased by her parents on an Italian trip. Joan had the elevator installed for her invalid mother.

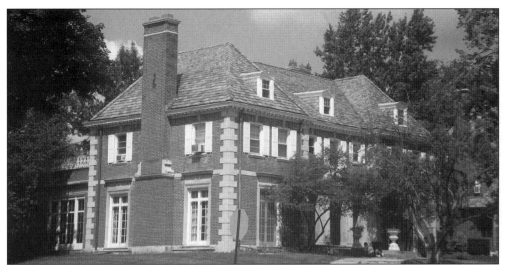

THE BRIGHAM HOUSE, 2049 RICHMOND ROAD, BUILT IN 1927. The Brigham house is one of the most elegant Westmoreland houses, reflecting the tastes of its English-born owners. The house was designed by architects Bollinger and Hayes for Jeremiah Brigham, a businessman and inventor involved in heavy manufacturing and the owner of three stamping plants. The floor plan is "I" shaped with sophisticated stone work on the recessed entrance porch, the quoins, and on the chimney.

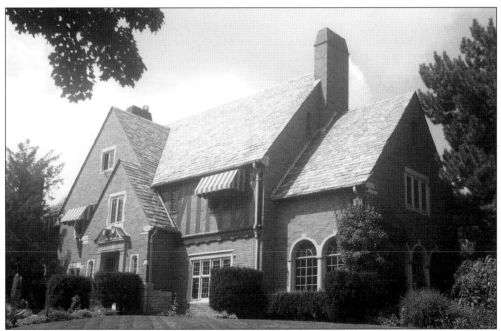

THE MOBURG HOUSE, 2051 RICHMOND ROAD, BUILT IN 1927. The owner of this house made his fortune from insecticides. Frank O. Moburg was the founder of the Rex Research Company, the makers of "Fly-Tox," and he had factories around the world manufacturing the product. His house is a fine English Tudor with half timbering, stone columns on the side porch, and a stone doorway surmounted by a broken pediment. The house is really a smaller version of one of the great Perrysburg riverside mansions.

DRUMMOND ROAD LOOKING SOUTH FROM CENTRAL AVENUE. This photo was taken on April 1, 1928 and shows some of the trees that gave Old Orchard its name. There were peach orchards near Pemberton and Middlesex Drives and an apple orchard at Densmore and Bancroft Streets. Badger Bowen laid out the one half mile square development giving the streets an urban gridiron plan and English sounding names. This section of Drummond has not been paved yet since storm and sanitary sewers are still being laid in the distance.

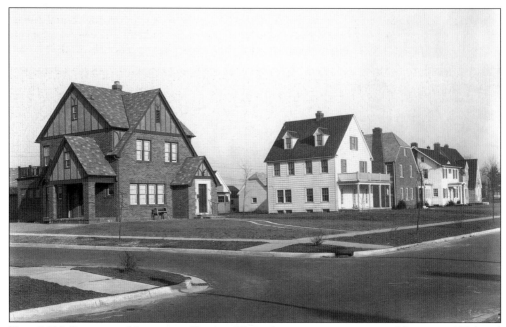

THE 2400 BLOCK OF MIDDLESEX DRIVE. These houses were constructed between 1926 and 1929, but five years into the Depression, only two still had their original owners. Two of the houses are colonial revival, one is Tudor, and two are a mixture of both. Young elm trees have been planted by the street.

THE MULHOLLAND HOUSE, 2425 MEADOWOOD DRIVE, BUILT IN 1926. Frank Mulholland was a labor attorney and co-author of the Railway Labor Act of 1934. His house is one of the best colonial revival designs in Old Orchard with a Dutch colonial style overhanging central porch. The front door is flanked by leaded glass sidelights and benches and bay windows with French doors. The neoclassical style cornice completes this picturesque design. (Photo by Korb.)

SUZANNE STREICHER ON MIDDLESEX DRIVE c. 1938. Suzanne sits in her wicker governess cart hitched to Billy with her dog Patsy. Billy was one of two ponies living in Old Orchard, eating grass at the back of their owners' double lots.

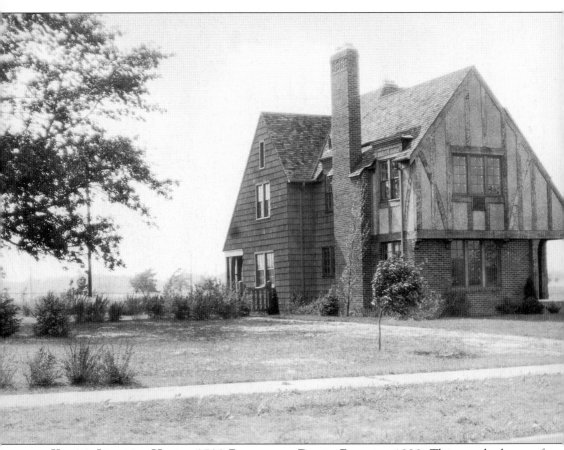

YONNIE LICAVOLI HOUSE, 2733 PEMBERTON DRIVE, BUILT IN 1929. This was the home of the famous mobster, located close to Central Avenue so he could high-tail-it up Secor Road over the state line into Michigan before a police car from downtown could arrive at his little Postwold cottage. The only evidence that Licavoli lived here is the presence of a safe room in the basement where he or his pals could hide out from the police. Born in St. Louis where he was first arrested at age 12, he became a member of Detroit's infamous "Purple Gang," running whiskey up in Detroit and later serving two and a half years for bootlegging. He came to Toledo in 1930, moving into this house with his new wife Zena and a bodyguard. An acquaintance described him, "He wore a silk shirt—monogrammed—beautiful cufflinks, a watch chain with diamonds in each link. He talked in a soft voice." Licavoli was indicted for bootlegging again in 1932 and found guilty, but the conviction was dismissed by the Repeal of Prohibition the following year. Police arrested some of Licavoli's associates at the house on suspicion of murder in 1933 as they were spending a relaxing afternoon playing croquet on the lawn. He was later indicted for several murders, and at his 1934 trial, the jury toured Licavoli's house to witness his idyllic home life with his baby daughter in her carriage on the porch and his two year old playing with her doll. He was convicted and spent 37 years in prison. He opened a stamp collecting shop after he was paroled in 1971.

Only a few blocks away lived Old Orchard's other celebrity, Mildred Augustine Wirt Benson, a long time Toledo newspaper woman, aviator, and author of 23 of the first 30 Nancy Drew Mystery stories. She wrote them to earn a living along with over 120 other juvenile series books, not for any lofty artistic reasons, and she was quite bewildered when she found herself a popular culture icon: "I'm so sick of Nancy Drew I could vomit." Her anonymity suited her, "I've kept it in the dark, especially locally, I didn't want to be pestered."

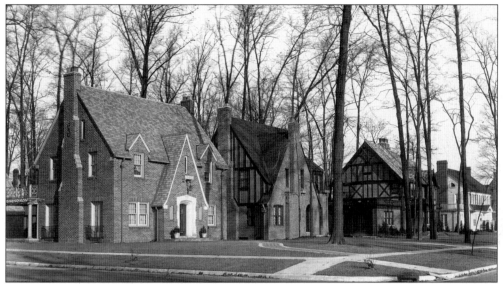

THE 2400 BLOCK OF MEADOWWOOD DRIVE. The original owners of these houses were lawyers, a bond trader, and a plant manager at the Mather Spring Company. They were living in houses that were much different from their parents' Victorian homes. Front porches have been removed in favor of a small entrance porch or often none at all. Porches have been moved to the side or at the rear and were often transformed into glassed-in sunrooms. Large entrance halls or stairhalls were removed in favor of the creation of a larger living room space. It was more common to have a small entrance vestibule and quite often the stairs were a part of the living room. There was generally only one bathroom on the second floor and sometimes a servant's or tradesman's bathroom in the cellar. Old Orchard would be the Toledo neighborhood most likely to be the setting for a 1960s TV sitcom.

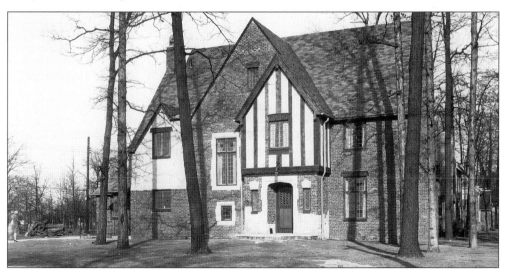

THE MILLER HOUSE, 2540 MIDDLESEX DRIVE, BUILT IN 1928. Life insurance agent Raymond Miller was the first owner of this Tudor style house. The exterior was a mixture of brick, half timbering, stucco, and stone with leaded glass windows of various sizes. The Kenwood Boulevard/Hopewell Place area still has superb old growth trees that survived when neighborhood elm trees were decimated in the late 1960s.

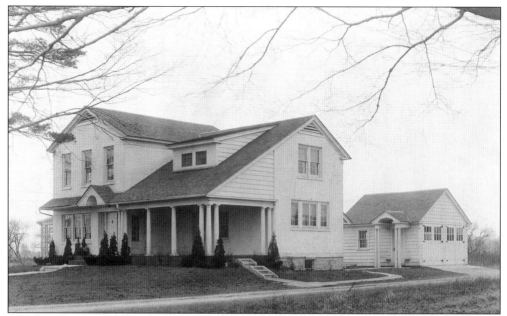

THE CROWLEY HOUSE, 3160 BANCROFT STREET, BUILT C. 1850. This was an old mid 19th-century farm house that was remodeled in the late 1920s to assimilate with the new houses. The porches across the front were new as was the garage with its own columned porch. All that's left of the original house are the brick walls. Glass company executive Joseph Crowley owned this house, and it has some of the finest Vitrolite bathrooms in the city.

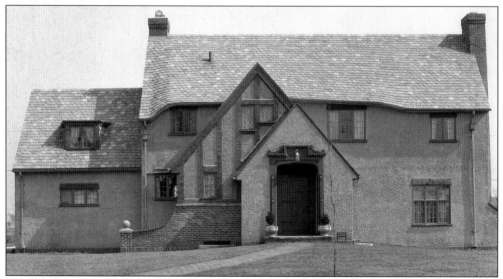

THE FOSGARD HOUSE, 2250 SECOR ROAD, BUILT 1929. Charles Fosgard, president and general manager of the Community Traction Company, was the first owner of this great house, and the architect was clearly influenced by the English Arts and Crafts Movement when he designed it. It has a slightly sloping roofline suggesting a thatched roof; the front gables are asymmetrical with a low stone wall terminating with a stone ball, making the house look more rambling than it really is. The entrance is carved wood instead of more expensive carved stone found in wealthier neighborhoods.

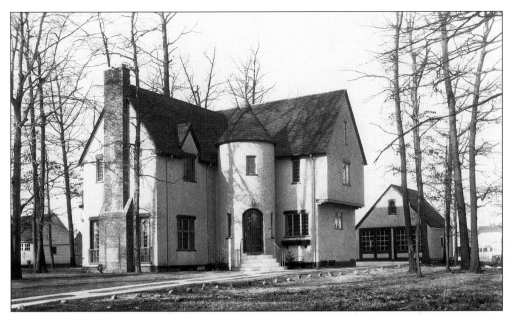

THE TALBUT HOUSE, 2423 BARRINGTON, BUILT IN 1928. Benjamin Talbut, a dentist, was an early owner. His stucco home was "L" shaped with an overhang on one end and a handsome chimney at the other end with leaded glass windows. The most interesting feature was the pointed tower enclosing the entrance giving the house a nice Grimm's Fairy Tale effect.

CHRISTMASTIME ON MIDDLESEX DRIVE IN 1933. Suzanne Streicher sits with her parents by their tree on Christmas Day. She is surrounded by little girl gifts: dolls, a baby buggy, kitchen utensils, a wash board, and a high chair. Suzanne didn't like these kinds of toys, preferring to play with her dog and pony. The pressed paper snowman candy container in the center of the photo still survives.

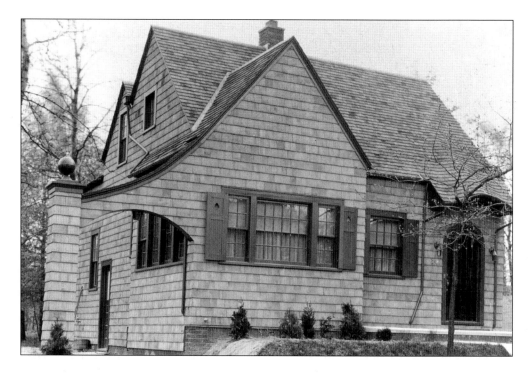

MIDDLE CLASS HOUSES. These unidentified Toledo houses demonstrate how developers were trying to make middle class housing attractive and individual looking. These two had the same floor plans but were simply reversed. By changing the materials and paint colors the houses appear to be totally different.

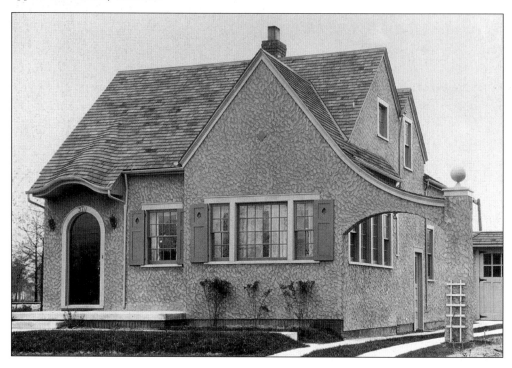

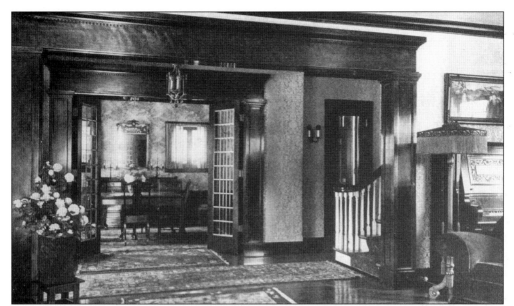

THE MEHRING HOUSE, 12 BIRCKHEAD PLACE. This view shows the interior of builder Carl Mehring's own home looking from the living room through the hall into the dining room. The rugs are oriental and Chinese. At the far right can be seen an upright piano and a floor lamp with fringed shade. The chair below them looks like part of one of the massive parlor suites so beloved by early 20th-century America, consisting of a matching sofa, chair, and rocker. The woodwork is stained and varnished, and leaded glass doors can shut off the dining room from the hall. This is an excellent depiction of an upper-middle class home after World War I.

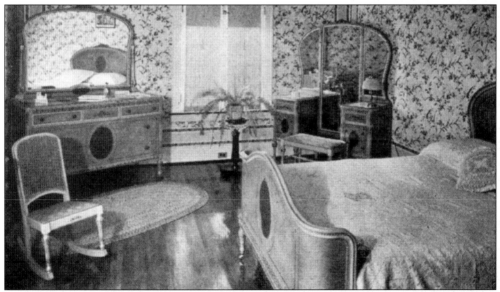

A BEDROOM IN THE MEHRING HOUSE. The bedroom was described here: "A delightful interior in the home of Carl E. Mehring . . . owes a full measure of its success to the attractive wall paper which adorns its walls." Only small area rugs cover the wood floors for easier sweeping. The bedroom suite consists of a matching bed, dressing table, and bureau with large mirrors angled to reflect light from the windows.

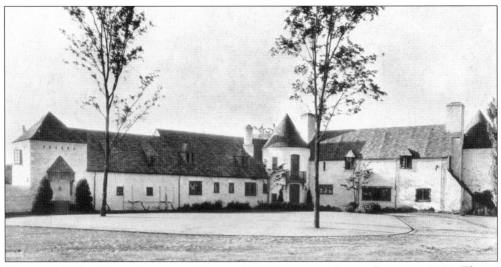

"Inlands," The Ward Canaday House, 4455 Brookside Road, Built in 1925. The Canaday estate was made up of 80 acres of cornfields by a forest overlooking Ten Mile Creek. Frank Forster was an architect from New York who specialized in the provincial architecture of northern France. Doreen Canaday Spitzer wrote about the building of her parents' house: "At the time, it seemed to me the three of us must have looked at . . . every chateau, every round tower in all of Normandy, for the plans called for the authentic re-creation of a Normandy farmhouse. . . . Most of the house was to be brick; the towers at each end—one round, one square—were of stone. The desired appearance—that it should look as if it had been standing for half a century—was built in from the beginning. Bricklayers, proud of their accustomed plumb-line accuracy, were with difficulty persuaded to lay carefully selected, irregular, warped bricks, in order to produce an effect of settled age. Roofers were reluctantly constrained to make the slate tiles ripple slightly, as if caused by the passage of time, over the timbers that held them. Two antique stone figures of crouching monks . . . were cemented in place as caryatids, supporting the wooden balcony above the front door. . . . There was great jubilation when those diamond-paned 'magic casements' were installed. . . . The exterior was whitewashed and then rubbed with metal brushes to give the desired aged effect."

Details of the Canaday House. This illustration shows from the upper left corner clockwise: The fountain head and lead cistern, possibly the front door, a view looking to the service court and garage, and the round front hall with its circular stairway.

(*above, left*) **THE TOWER OFF THE LIVING ROOM.** A great number of antique stone architectural fragments purchased in France were incorporated into the structure and around the gardens. Daughter Doreen wrote, "Inlands, over the next half century, would grow into a beautiful estate. It would be at times a home, a prison, a showplace, a country club, an enchanted castle, an office, even a hell, and often a paradise. Inlands was an expression of Miriam's personality, her taste, her values; of Ward's imaginative vision, his energy, his pecuniary strength."

(*above, right*) **THE TOWER ROOM.** Doreen Canaday Spitzer wrote, "A lady artist was engaged to paint frescoes—little provincial scenes, landscapes, flowers, our intertwined initials W M and D—in the deep window embrasures and on the walls off the round tower room, while just under the ceiling marched Miriam's favorite mottoes . . . 'I have sometimes been punished for speaking, never for keeping still' . . . the house was to reflect the artistic quality craftsmanship, and timelessness of the Old World."

(*right*) **THE DOOR TO THE LIBRARY.** Miriam Canaday decorated the house herself and bought heavily: "In the wake of the trip to Europe appeared crates of carved panels, armoires, chests, tables, chairs, statues, Quimper pottery, and bric-a-brac."

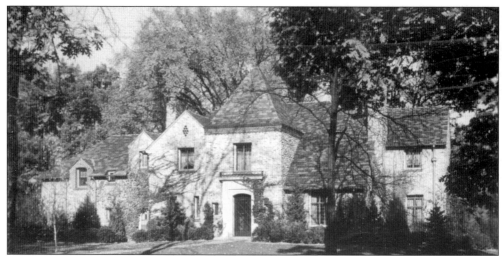

THE EFFLER HOUSE, 3532 RIDGEWOOD ROAD, BUILT IN 1929. The Mills, Rhines, Bellman, and Nordhoff firm designed this field stone house for attorney Erwin Effler, and it is one of several French Norman farmhouses in Ottawa Hills. The interior is of the highest quality with French mid 18th-century-style paneling.

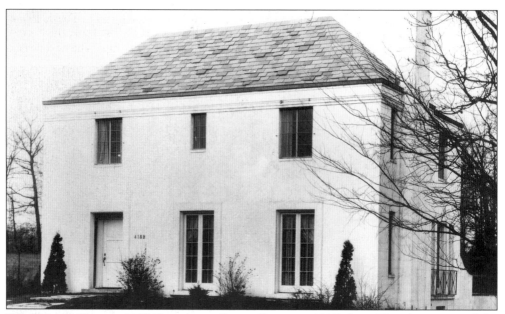

THE TEMPLE HOUSE, 4152 BROOKSIDE ROAD, BUILT c. 1935. Leon Temple was one of the largest independent bus operators in the country; his Short Way Bus Lines Company, founded in 1921, operated 60 buses in southern Michigan and Ohio. Begun at the height of the electric interurban trolley line's popularity, buses gradually drove the trolley lines out of business.

The Temple house was a rare example of the "Moderne" style translated into a house design. Usually associated with skyscrapers and commercial buildings, the stone house had only the most minimal decoration with simple moldings around the first floor windows and cornice. The slate roof was the house's most decorative element. This house was altered several decades ago in a way that reminds one of the alterations done to the Rummel house at Parkwood and Bancroft Street. (Photo by L.J. Billman, PL.)

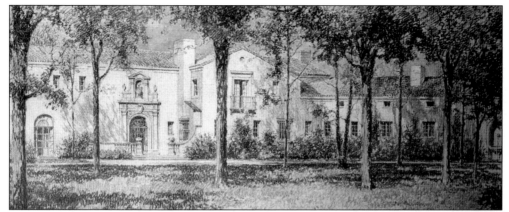

"SHEERNESS HOUSE," THE WILLYS-RITTER HOUSE, 4555 FOREST VIEW DRIVE, BUILT IN 1923–1924. John North Willys was a major financial backer of Ottawa Hills so it would only be logical to assume that he would be able to acquire one of the prime parcels of land—40 acres on a scenic bluff overlooking the Ottawa River. Mills, Rhines, Bellman, and Nordhoff designed a Spanish style home of stucco with a tile roof, wrought iron window grills, and an arcaded gallery. After the stock market crash, the house was sold when Willys Company went into receivership. Doreen Canaday Spitzer wrote, "When he was appointed ambassador to Poland he sold his common stock in the company, the stock market crash followed almost immediately, and the company went to pieces. Mr. Willys relinquished his post in 1931 and returned to Toledo to put the pieces back together again. On the day he was to get a loan from a Detroit bank, the Detroit banks closed . . . bills could not be met. Willys-Overland went into receivership." The next owner, Marshall Sheppey, was the retired head of the Berdan wholesale grocery company. He named it "Sheerness House" and added a wing and an elevator. George and Mary Ritter purchased the house in 1948; Ritter was Mr. Willys' former attorney and with Ward Canaday was credited with saving the Willys Company from financial ruin and reorganized it as Willys-Overland Motors, Inc. After Mr. Ritter's death, the estate was transformed into a subdivision.

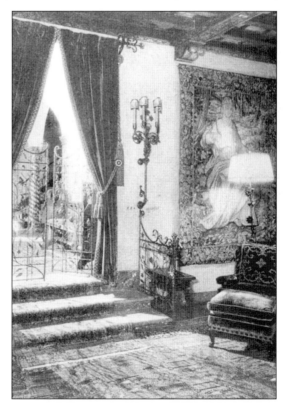

JOHN NORTH WILLYS' LIVING ROOM. Willys and his family lived in New York, but he made frequent business trips to Toledo, so having a large house where he could entertain clients was important. Willys was an art collector and a man of taste, and his house was filled with tapestries, paintings, and antique furniture. This view of the living room, like something right out of *Sunset Boulevard*, displays a wide range of highly decorative wrought iron-gates, a railing, a torchere, a drapery rod, and a floor lamp.

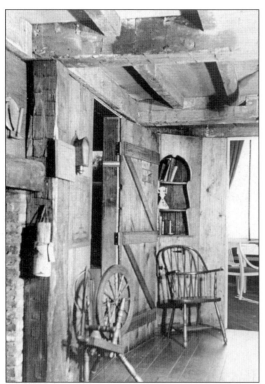

THE OFFICE OF KARL HOKE, 1217 MADISON AVENUE BETWEEN TWELFTH AND THIRTEENTH STREETS. Karl Hoke was one of Toledo's great residential architects, and his most prolific period of creativity was during the 1930s. He was a master at designing houses that looked old and picturesque. He was known to use salvaged materials from demolished buildings, and two of his Ottawa Hills homes are built with brick salvaged from the old Smead School. His office was planned to show the scope of his talents; the reception room in the foreground looks like a 17th-century American house complete with beamed ceiling, a spinning wheel, and a Windsor chair, while in the background is a conference room decorated in modern stylized classical taste.

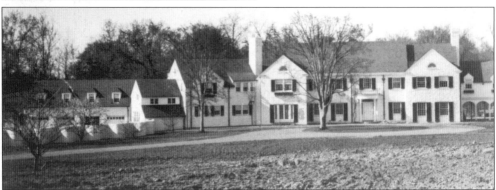

THE BIGGERS HOUSE, 4365 BROOKSIDE ROAD (NOW 2425 BROOKVIEW ROAD), BUILT IN 1933–1934. John Biggers was the first president of the Libbey Owens Ford Company after it was founded through a merger in 1930. After the value of his LOF stocks began to rebound, he decided to buy property and build a permanent home for his family after years of living in rented houses. Biggers said, "This was a nice, slightly rolling homesite, extending from Brookside Road back to the river. . . . We bought this property . . . and with the aid of Karl Hoke, a competent and highly regarded architect, patiently and ploddingly worked out the plans for our home. . . . This being our first home we worked meticulously on architecture, interior arrangement, and all the many details involved in plumbing and electrical system and what seemed like a thousand other things. . . . The house turned out to be very comfortable, well built, and quite attractive architecturally." The property was 23 acres with almost a dozen acres of lawn cut by gardeners earning 30¢ an hour and wooded acreage in the valley near the creek. "We spread 1,630 truck loads of top soil on our acreage . . . and the Scott Seed Company, for a number of years used varying pictures of our lawn in their catalogs demonstrating what could be accomplished with their seed," said Biggers.

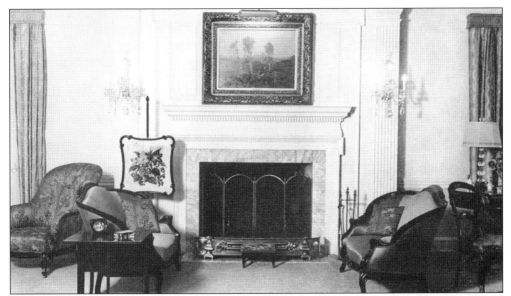

THE BIGGERS HOUSE LIVING ROOM. Lillian Pope and her daughter Mrs. Hubbard furnished interiors for the carriage trade "by appointment only". Karl Hoke installed fine, English 18th-century-style woodwork, and Mrs. Pope decorated with Victorian furniture, crystal sconces, and a modern crystal lamp. Wall to wall carpet, popular in the 19th century, had returned to fashion.

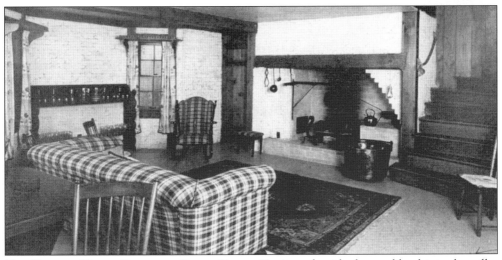

THE BIGGERS HOUSE BASEMENT PARTY ROOM. Having a furnished room like this in the cellar was a rather innovative idea derived from turn of the century men's smoking rooms or billiard rooms. Here the Biggers and their guests could sit by the fireplace with a collection of cooking tools just like their forbearers did.

Building a house like this employed a lot of people during hard times. John Biggers reminisced, "I especially am able to remember the brick mason contractors. The father's name was Capaletti. He was a fine Italian-American. He had six sons, and they had all been taught to work, so they . . . worked indefatigably on this job and were always a source of pleasure and gratification to me because when I finished my days work downtown with LOF, I would drive out to this new house and look things over in the early evening. Invariably all the workmen had left except the Capaletti's, and I would usually find seven of them at work laying brick or stone."

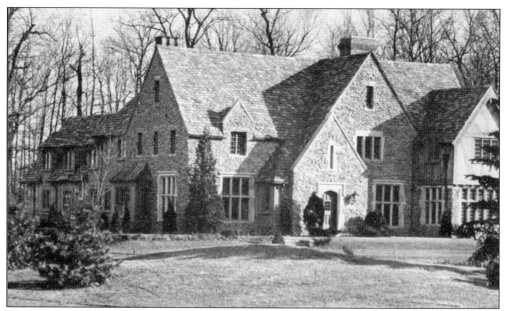

THE WOLFE HOUSE, 4540 BROOKSIDE ROAD, BUILT c. 1935. This house was also designed by Karl Hoke, and he produced a fieldstone English manor house with half timbering and lots of gables. Owner Harry Wolfe owned the American Floor Surfacing Machine Company and belonged to the Tile Club.

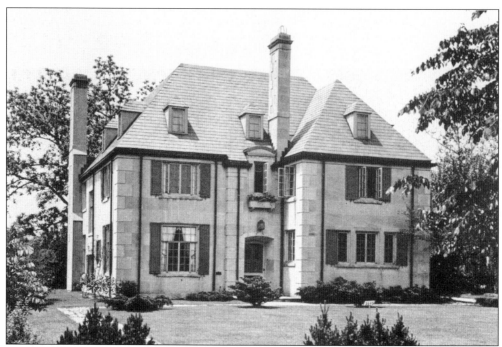

THE HAAS HOUSE, 3545 BROOKSIDE ROAD, BUILT c. 1936. The original owner Cloyd Haas was president of the Haas-Jorden umbrella manufacturing company and a former Inverness president. Karl Hoke designed this beautiful small French chateau of smooth stone with rusticated quoins and a hipped roof with dormers.

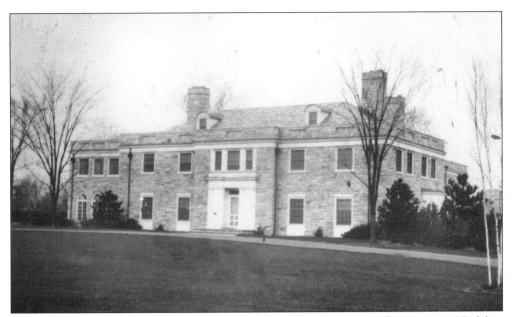

"HEARTHSTONE," THE TERHUNE HOUSE, 4342 BROOKSIDE ROAD, BUILT IN 1937. Most people recognize this house surrounded by a high stone wall. The house was designed by architect Myron Hill for lumber heiress Alice Terhune. It was built like a bunker of steel and concrete with stone on the exterior. Twenty-one birch trees were planted on the grounds. It had 23 rooms, a marble hall, nine fireplaces, and lots of cats. Miss Terhune was a great animal lover, known as the "cat lady," and she owned scores of cats. She lived in three second-floor rooms with a longtime female companion and rarely ventured downstairs. In 1971, the house was the scene of a major estate sale, and admission was charged just to look around inside. (PL.)

MEMBERS OF THE OTTAWA HILLS TENNIS CLUB, TALMADGE ROAD AND INDIAN ROAD, BUILT IN 1928. Four men in this picture are wearing the new style in tennis shorts. Situated on a three-acre site, the clubhouse was designed by Horace Wachter, and 15 tennis courts were built. Many notable celebrities such as Bill Tilden played here. In the mid-1990s, the clubhouse was the scene of the most unusual duct tape-related death in Ottawa Hills history. (PL.)

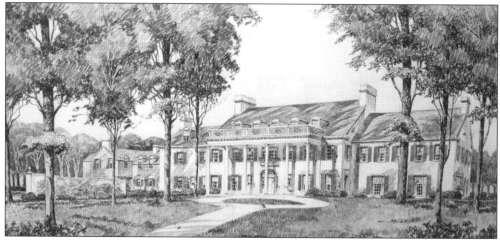

"STRANLEIGH," THE ROBERT STRANAHAN HOUSE, 5100 WEST CENTRAL AVENUE, BUILT IN 1936–1938. Robert Stranahan owned one of the first houses built in Ottawa Hills on Orchard Road, but by the mid 1930s, he wanted a large estate where he and his family could entertain, ride horses, and swim. Stranahan had remained a wealthy man through the Depression because people still needed spark plugs for their autos.

The house was designed by Mills, Rhines, Bellman, and Nordhoff with Karl Hoke as associate architect, and it was constructed of 12-inch steel beams, concrete, and brick. The house resembles the columned plantation houses of Mrs. Stranahan's native Virginia, though the house also has a strong resemblance to the Gertrude Vanderbilt Whitney House in Westbury Long Island. The mansion suggests a house that has evolved over time through additions from a frame farmhouse to a much larger brick main house. This elevation drawing shows the house before the building materials had been decided. It was completed in 1938 at the cost of $340,000.

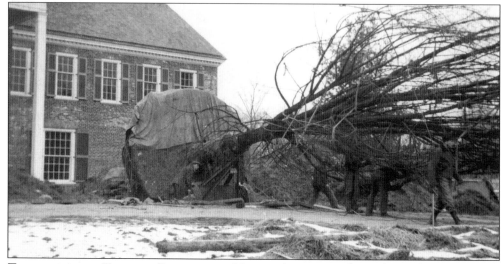

TRANSPLANTING TREES AT STRANLEIGH. Here workmen transplant a large elm tree in front of the newly completed house. The estate was roughly one square mile in the valley of Ten Mile Creek or about 753 acres. About 100 men were employed, clearing wooded areas, cleaning the creek, and rearranging its boulders to create rapids. A chestnut rail fence was built around the property. Seven wells were dug for the stock and gardens, and originally there was talk of building a landing strip. (Metroparks.)

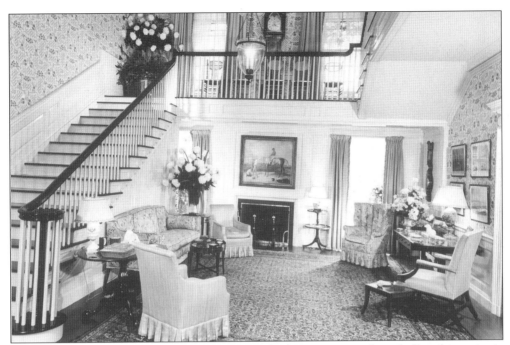

THE FRONT HALL AT STRANLEIGH. The house had an impressive front hall with a majestic staircase and 35 principle rooms, including 15 bedrooms, 17 bathrooms, and 16 fireplaces. A staff of ten took care of the house and lived in the servants' wing and in several small cottages on the property.

GUESTS AT THE WEDDING OF BARBARA STRANAHAN. It was not unusual for the Stranahans to give parties for 500 people with guests enjoying the house, gardens, and pool. These guests were attending the 1946 wedding of daughter Barbara. Mimi Rorick is on the left and Mr. and Mrs. Mel Lewis are on the main staircase. One can see a detail of the original wallpaper, which still exists. Mimi Rorick's mother, Alice Scott Rorick, wrote a novel, *Mr. And Mrs. Cugat*, about an American married to a Cuban bandleader; the rights were purchased by Lucille Ball, and it was developed into a radio program and later her famous television show.

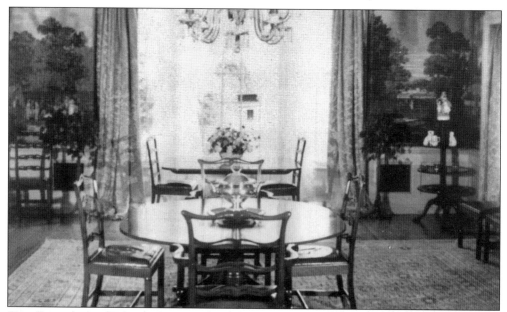

THE STRANLEIGH DINING ROOM. The greatest feature of the dining room was the hand-blocked French scenic wallpaper. The furniture is 18th-century English with possibly some American pieces. Silver was stored in a vault off the kitchen.

The house was heated by five oil furnaces, and the main part of the house was air conditioned. The first room air conditioners went on sale in 1932, and they were expensive but they gradually ended the ritual of front porch sitting. (Metroparks.)

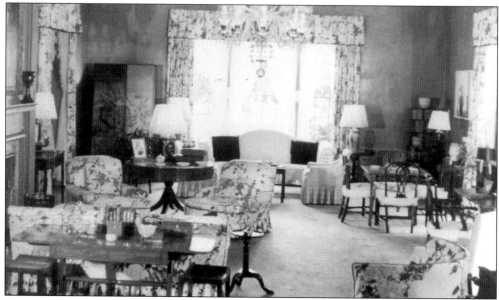

THE STRANLEIGH LIVING ROOM. The living room was decorated in shades of pale green and gray with chintz curtains that matched the slipcovers on the comfortable looking chairs. A bridge table is set up in the right corner, and the table in the foreground holds a collection of 18th-century wooden tea caddies. Items from this house purchased at the auction following Mrs. Stranahan's death still have great cachet in Toledo collecting circles. (Metroparks.)

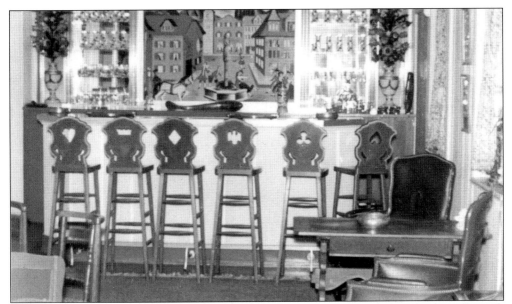

THE STRANLEIGH PARTY ROOM. This view of the bar room shows one of a series of murals depicting popular games. The basement was often used for parties during the winter months particularly spaghetti suppers. There was also a grill room, recreation room, and shooting gallery. The security guard kept the key to the liquor supply. (Metroparks.)

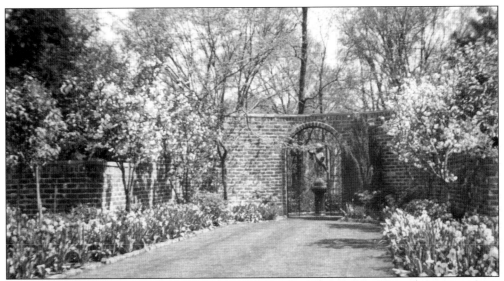

THE FORMAL GARDEN. The gardens were designed by Ellen Biddle Shipman, a pioneering female garden designer. She brought a new sense of sophistication to traditional American garden design without losing her fondness for simplicity. Each design was a new response to a set of unique circumstances arising from the character of site and the character of client: "I feel strongly that each garden that I do is like a portrait of the person and should express their likes and dislikes." Her work displayed a distinctive planting style intertwined with architectural features that created "outdoor rooms," separate from the rest of the landscape. The Stranleigh gardens could be illuminated with colored lights, and two gardeners worked full time mowing grass, pruning trees, shrubs, and weeding gardens. (Metroparks.)

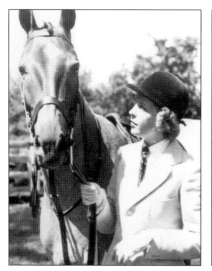
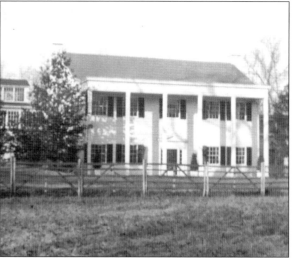

THE RIDING ARENA. The family enjoyed fox hunting, and the stable usually housed about ten horses. The photo on the left is of Barbara Stranahan with her horse. Some old National Guard Calvary Barns originally at Upon Avenue and South Cove Boulevard were moved here and remodeled into an indoor riding arena with the ground covered in a layer of red cedar sawdust. The columned party room in front of the arena had two fireplaces, an orchestra stand, and a service kitchen. The building was later demolished. In 1974, county residents voted for a tax to purchase the estate which was about to be subdivided and create the Wildwood Preserve Metropark. (Metroparks.)

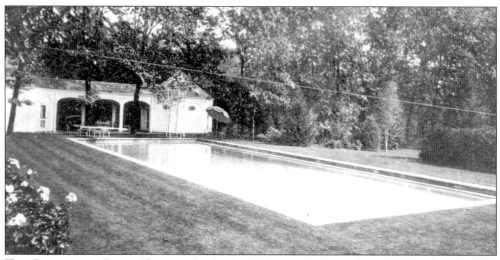

THE STRANLEIGH POOL. This was the 25- by 70-foot pool. It was later filled in, but the pool houses still stand. Son Frank Stranahan, Jr., a champion golfer and weightlifter and considered one of Americas most eligible bachelors in the late 1940s, stated, "I've often said that I've traveled all over the world, but it was the most beautiful place I've ever been. I still say it to this day."

Five
DEPRESSION

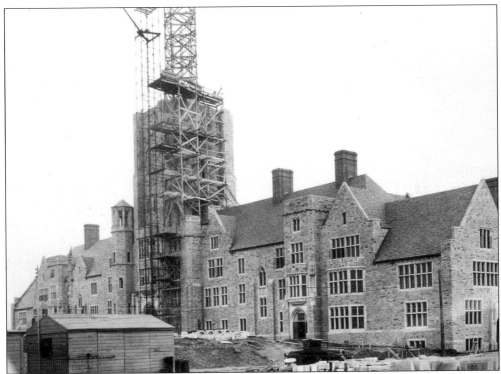

UNIVERSITY HALL, 2801 WEST BANCROFT STREET, BUILT IN 1931. The university was founded in 1872 by Jessup Scott, and after years of money woes and a series of temporary headquarters, the school began to look for a permanent campus. Ninety-two year old Albert Macomber, an original university director from the earliest days, suggested moving to an 80-acre farm on West Bancroft Street. The farm was purchased with an additional 34 acres, and the *Blade* wrote, "Those who stand on the new site see stone and steel forming a tangible reality for years of dreams of a great municipal institution of learning. A hope is rising in architectural splendor."

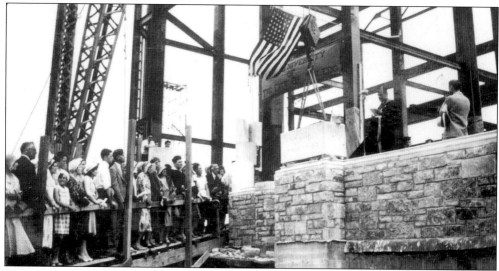

UNIVERSITY PRESIDENT HENRY DOERMANN SPEAKING AT THE CORNERSTONE LAYING IN 1931. President Doermann stated, "We believe you are going to respond to the challenge of a beautiful environment, that the traditions which have grown up about this noble architecture will stimulate you to greater efforts in learning, and to finer decorum, and to a deeper resolve to use your education to further truth, justice, and beauty." (UT Canaday Center.)

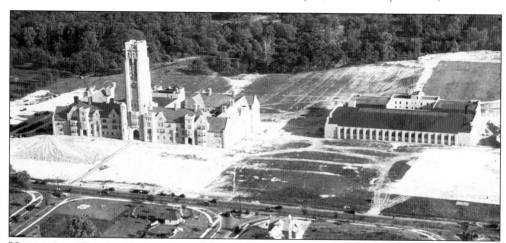

UNIVERSITY HALL AFTER COMPLETION. The Tudor gothic style was popular in America for college campuses before the Civil War and became almost the established style after the turn of the century. It was popularized by architect Ralph Adams Cram and an American admiration for Anglo-Saxon heritage. University Hall was designed by Mills, Rhines, Bellman, and Nordhoff and has similarities to buildings at Princeton University and at the University of Chicago. The façade was asymmetrical with pointed arches, battlements, niches without statues, gargoyles on the tower, and other carved decoration. There were 337 rooms on six levels with courtyards in the east and west wings. The 205-foot tower cost $75,000, and its construction was debated, but President Doermann fought for it as an important symbol of the school. The structure was constructed by 400 men in 11 months with 50,000 tons of limestone. The Field House, the second building on the campus, was a more utilitarian building used as a gym and for basketball games, concerts, and commencement exercises. Since the opening of Centennial Hall in 1976, the Field House has been little used. (UT Canaday Center.)

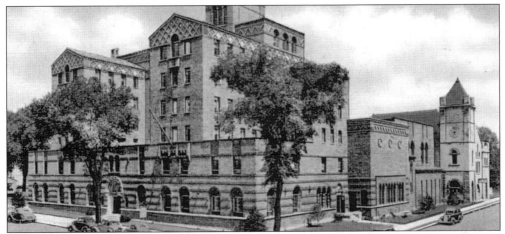

THE YMCA, JEFFERSON AVENUE BETWEEN ELEVENTH AND TWELFTH STREETS, BUILT IN 1932–1935. One of Toledo's largest fund raising campaigns raised $1.5 million for construction of a new YMCA in 1928. The Depression delayed completion until 1935. The *Blade* wrote it was "a monumental retort to the material and spiritual blight of economic disaster." The base of the Jefferson Avenue building contained social rooms and business offices with 152 residence rooms above. The rear of the building contained the pool, gymnasium, and handball courts.

Talented John Richards, a member of Mills, Rhines, Bellman, and Nordhoff, executed the working drawings. He wrote, "The style chosen is a free interpretation of the Lombard Romanesque, which developed in the northern portion of Italy from the 11th to the 13th centuries. . . . The building is not ornate and depends, for results, largely on the arrangement of the masses and the color and pattern of the brickwork." The building was indeed one of Toledo's most colorful—from the roof tiles to the brick and the window glass. Ironwork was adapted from the Court of San Ambrose in Milan. The interior had an interior court and a great deal of stenciled decoration on ceilings and shutters. Parts of the design were scaled down due to the Depression

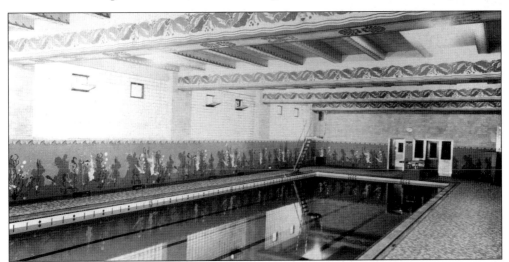

THE YMCA POOL IN 1935. The Y closed in 1980, citing a declining transient population. After plans for conversion to residential units fell through, the building sat vacant for years. The building was bought by the county at a sheriff's auction and converted into a community-based correctional facility with up to 100 nonviolent felony inmates in dormitory settings with a new juvenile treatment facility constructed at the rear. (Photo by Mensing, PL.)

111

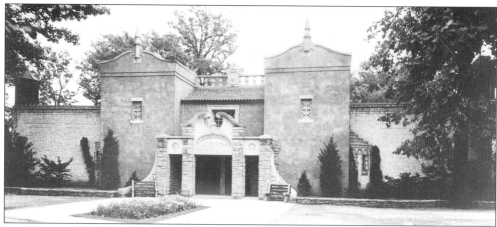

THE REPTILE HOUSE AT THE TOLEDO ZOO, BUILT IN 1934. Franklin Delano Roosevelt proposed the Works Project Administration in 1935, and many unemployed Toledoans were put to work on major building projects, including construction of the Anthony Wayne Trail, the University of Toledo football stadium, and other street and sewer projects. Some 1,300 men were working at one time in 63 trades under the WPA. Wages were lower than in the private sector, but they were still higher than receiving direct relief payments. Unskilled workers earned $55 a month; skilled workers and professionals earned $90–$100 a month.

The Zoo was transformed by the WPA, and by the end of 1937, an aquarium, aviary, amphitheater, and reptile house had been completed. The reptile house was designed by architect Paul Robinette, and while they had the completed design and the workers were ready to build, new materials were scarce, so they were obtained from demolished Toledo buildings. The Reptile House was constructed of brick from Jefferson School, Toledo Hospital, and the Milburn Wagon Works, stone and wood from the Wabash Railroad Shops, and stone from nearby canal locks. At the 1934 dedication, Director Skeldon stated, "This building will stand down through the ages as a monument to work relief . . . as a tribute to the men and women who labored with heart and soul in their appreciation of the opportunity to work." (PL.)

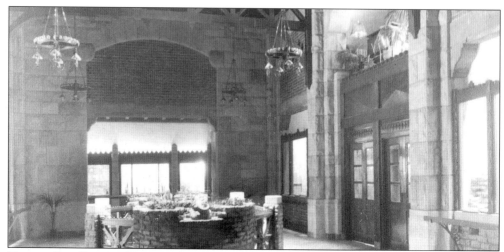

TOLEDO ZOO REPTILE HOUSE. This 1934 photo shows the cave-like reptile house at the time of its completion. The railings were pieces of walnut caulk dug from the canal bed. The ceiling was made from wooden packing crates that held shoes sent to needy Toledoans. The stone for the floor was obtained from old Cherry Street sidewalks and the Maumee Riverbed. (Photo by Korb, PL.)

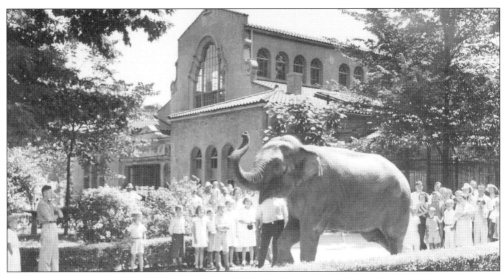

BABE THE ELEPHANT WITH HIS HANDLER, LOU SCHERER, IN 1938. Babe was an ex-circus elephant who had killed one of his keepers. He was purchased by public subscription in 1912 and at 8,000 pounds was said to be one of the largest elephants in captivity: "Babe eats two great bales of hay daily, a large pail of oats, and plenty of vegetables." He had a habit of escaping, and the daughter of zoo director Frank Skeldon reminisced, "He came through all our yards. He took the railing off this porch one time. . . . He ate the flowers off people's lawns, geraniums, hundreds of geraniums. He held a woman coming up the stairs. She went to come down and he'd stick his trunk in her window; she couldn't come down the stairs." In 1915, his second keeper struck him on the trunk, and Babe killed him by hitting him and kneeling on him. Here Babe stands in front of the Spanish-style Lion House, designed by Architects Stophlet and Stophlet. Kermit Roosevelt, son of Teddy, was at the ground breaking in 1924 though the building wasn't completed until 1927. In 1993, it was converted into the Carnivore Café. (Photo by Zink, PL.)

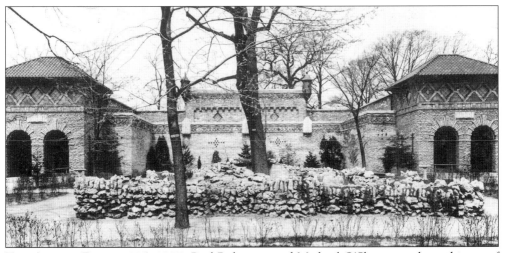

THE AVIARY, BUILT 1935–1937. Paul Robinette and Michael O'Shea were the architects of the building housing a collection of over 650 exotic birds plus domestic species. The building was stone with brick and tile decoration with much more texture than the zoo's stucco buildings. Innovative glass block made by the Owens-Illinois Company was used here. (Photo by Zink, PL.)

THE AUTHOR AND HIS SISTER IN 1960. From 1934 until 1936, artist Arthur Cox sculpted a series of animals out of stone blocks from the old canal locks including a bison, a hippo, a rhino, and an elephant. Cox also sculpted the dolphin fountain near the entrance and several works in the Reptile House.

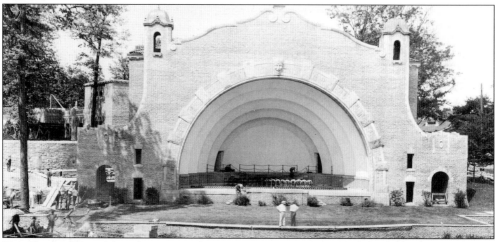

THE TOLEDO ZOO AMPHITHEATER, BUILT 1934–1936. An Amphitheater, an indoor theater, and the zoo museum are interconnecting buildings designed by architects Robinette and O'Shea. The music shell is a 70-foot arch, and four feet below the shell is an outdoor stage with a depth of 50 feet and a 110-foot apron. The copper on the Spanish domes came from the demolished Milburn Wagon Works. Brick and stone came from demolished schools and the Wabash roundhouse. The carved stone mask at the top of the arch and the other large blocks around it were from canal locks. The Amphitheater seats approximately 5,000 people.

Since the theater is outdoors, it was impossible to design any sort of curtain; instead the architect designed a water curtain, which threw a wall of water about 15 feet into the air curling and falling into a reflecting pool in front of the stage and lit by colored lights. It was said that at the grand opening there were swans swimming in the pool, and the pump for the water curtain didn't arrive in time, so a fire pumper was sent to fill in. The Zoo's "Music Under the Stars" program has been a popular attraction for almost 70 years. (PL.)

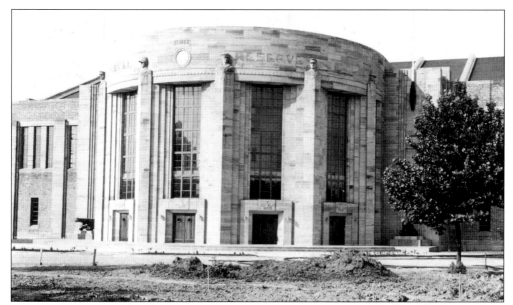

THE BAY VIEW ARMORY IN BAY VIEW PARK, BUILT 1934–1935. The Armory was another WPA project, and like many zoo buildings, it was designed by Paul Robinette and constructed of materials salvaged from Toledo buildings, including brick from demolished smokestacks. The interior resembled a ship with a bridge overlooking a drill deck with two six-inch guns equipped with lights allowing gunners to simulate firing by aiming light beams at targets. Also inside were three WPA murals depicting the Battle of Lake Erie by Paul Breisach. Figures representing various branches of the naval service are carved at the tops of six piers surrounding the circular entrance. The building has been vacant since 1995. (PL.)

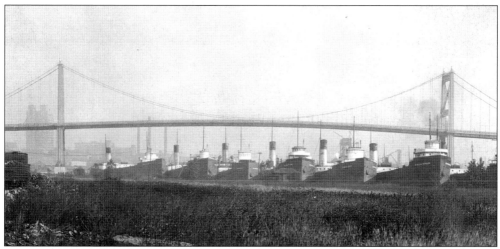

TOLEDO HIGH LEVEL BRIDGE, BUILT 1930–1931. The High Level Bridge, designed by the engineering firm of Waddell and Hardesty, was the first bridge crossing the Maumee that didn't have to be opened for ship traffic. The official inauguration took place on October 27, 1931, during the depths of the Depression, and Toledoans were offered free transportation downtown with big sales at downtown stores. The *Blade* wrote, "with a pair of gilded scissors, Mayor Jackson will turn on the great system of lights, which has been installed on the bridge. He will then cut the ribbon at the eastern end of the bridge and will ride across in a new Willys-Knight sedan."

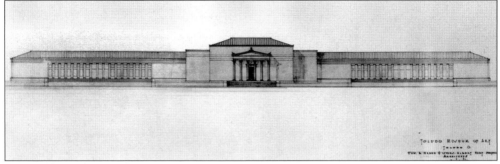

A Proposed Addition to the Toledo Museum of Art. World War I delayed expansion plans to the original 1912 building until 1926 when a rear addition squared out the original structure, doubling exhibition space and enlarging the old Hemicycle into an 800-seat auditorium, and the rear of the building now had an Ionic colonnade matching the front.

At the request of Mrs. Libbey, a massive expansion, tripling the size of the building, was carried out from 1931-33. This is a 1930 drawing showing a proposed addition to one end of the original building with a new central section and matching wing. (TMA.)

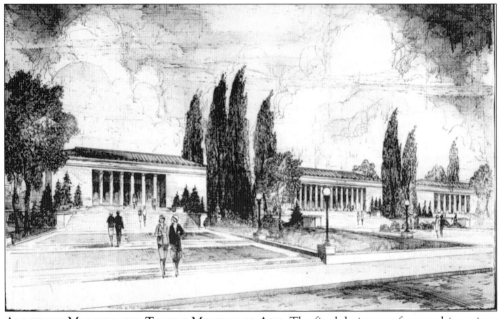

Additions Made to the Toledo Museum of Art. The final design was for matching wings with shortened colonnades, steps, and terraces flanking the original building. The grounds were landscaped with mature trees, some transported in railroad cars on specially laid tracks.

The 1982–1983 renovations by Hardy, Holzman, and Pfeiffer of New York realigned the main entrance to the rear, providing ground floor access but close to the gift shop, restaurant, and rest rooms. Renovations in 1991 resulted in realigned galleries but incorrectly designed skylights were installed at this time which spoil the silhouette of the building with boxy roof projections.

The most recent changes involved redesigning the grounds in front of the building by Laurie Olin in 1996 with a sculpture garden. The focal point of the scheme was the installation of *Stegosaurus*, the $4.1 million sculpture designed by Alexander Calder in 1972–1973, placed directly in front of the main entrance. One Toledoan called it, "optimistic, dramatic, yet whimsical." Another said, "It tarts up the elegant neoclassical façade like a piece of cheap costume jewelry."

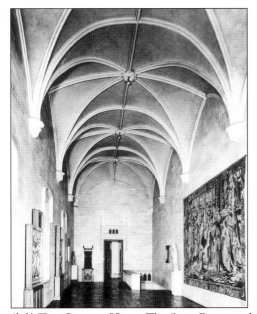

(*left*) **THE GOTHIC HALL.** The Swiss Room and the Gothic Hall were both installed in 1926. The Gothic Hall was constructed as a backdrop for the display of tapestries, sculpture, and stained glass and physically connected the two groups of gallery spaces at each end of the building. Later administrations decried its lack of authenticity, and it was demolished in 1982 as part of the Hardy, Holzman, and Pfeiffer renovations for temporary exhibition space. (TMA.)

(*right*) **THE CLOISTERS.** The Cloisters was installed in 1933 after the museum purchased three sets of arcades taken from medieval cloisters; the fourth set of columns is modern wood. This watercolor shows the space planted with lawns and shrubs. (TMA.)

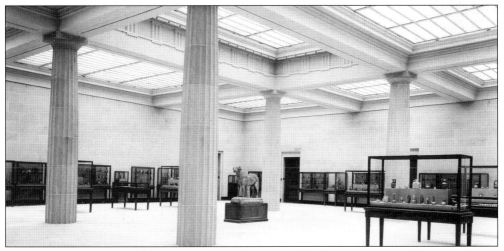

THE CLASSIC COURT. This 1933 space is dominated by four monumental Doric columns supporting a skylit roof. The Roman sculpture of a ram, once part of the famous collection of Sir Thomas Hope, was long a favorite with the public, but parts of it, particularly the head, turned out to be late 18th-century "restorations," so it has been banished along with the ancient Egyptian mummy that long resided here—the favorite exhibit of every child. All of the skylights except the central atrium have recently been covered over. (TMA.)

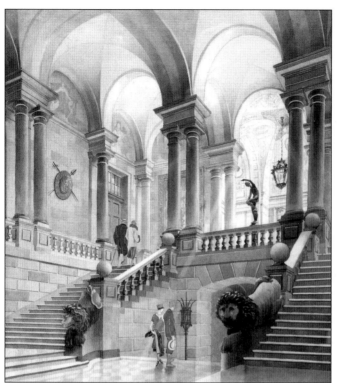

A Proposed Entrance to School of Design. Mrs. Libbey was a practical woman, and she rejected this proposal for a palatial entrance to the school of design in the new west wing, feeling it was much too grand and that the money could be better spent elsewhere. (TMA.)

A Proposed Design for a Classroom. The Museum offered adult classes during the week and taught thousands of children on Saturday from ages three and up. The School of Design was the brainchild of Director George Stevens, and it was begun in 1919, offering courses in drawing, painting, learning about the collection, and listening to music. The interaction of art and nature was important, with drawing classes often held outdoors and birdhouse building. In 1969, the glass crafts building was completed, offering the first classes in glass blowing at any American museum. (TMA.)

THE PERISTYLE AT THE TOLEDO MUSEUM OF ART, BUILT 1931–1933. Music was important to Mrs. Libbey, and she saw to it that it was included in the art education program and provided the funding for construction of the Peristyle. Mrs. Libbey had the architects design a theater based on an ancient peristyle open to the sky. A contemporary source wrote, "(Construction) has provided employment for laborers and skilled workmen when employment was most needed." The construction photo looks more like an archeological excavation than new construction. (TMA.)

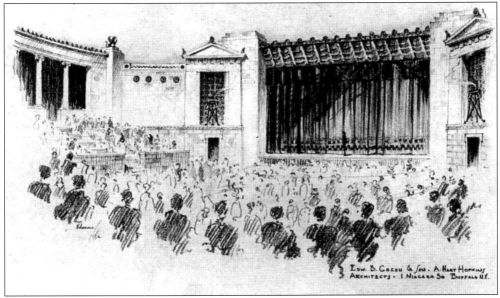

AN ELEVATION DRAWING OF THE PERISTYLE. Edward Green and Sons of Buffalo, the architects of the original museum building, were also the architects of all the museum renovations in the 1930s. Opening night was on January 10, 1933 with a performance by the Philadelphia Symphony Orchestra, conducted by Leo Stokowski, playing Brahms, Wagner, and Stravinsky. The Peristyle seats 1,750 people and was designed with an innovative suspended acoustical ceiling. The space has been underutilized as of late and demolition was pondered for additional gallery space in the mid 1990s. (TMA.)

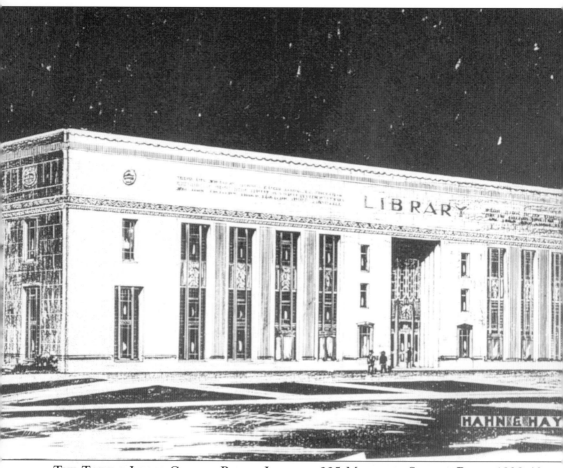

The Toledo Lucas County Public Library, 325 Michigan Street, Built 1939-40.
The library is downtown Toledo's best example of the Modernistic/Art Deco style—a style neither traditional nor truly modern. Art Deco buildings are generally massive in form and covered with a masonry skin, but enlivened by stylized geometric decoration. Aluminum was a popular material for this streamlined style and was employed here in the recessed window frames and the doorway. A characteristic feature were the corners that don't meet and the bands of geometricized decoration wrapped around the top of the building with Fort Industry blockhouses at each corner. Architects Hahn and Hayes appear to have been influenced by the recently completed Folger Library in Washington D.C. and construction was largely financed by the Public Works Administration with WPA work crews.

A major addition was made to the rear of the old building, increasing the library's size by 50 percent. The $35 million cost was financed by a bond issue and work was completed in 2001. At this time, the old building was lovingly restored. (PL.)

THE ENTRANCE LOBBY STAIRCASE AT THE LIBRARY. The new library showcased a number of glass products developed by Toledo Companies, including glass block trim around windows, "Thermolux" skylight glass, and "Industrex" used in lighting fixtures. "Vitrolite" was colored glass used for covering walls and building façades. The primary Vitrolite colors in this photo are black and salmon. (PL.)

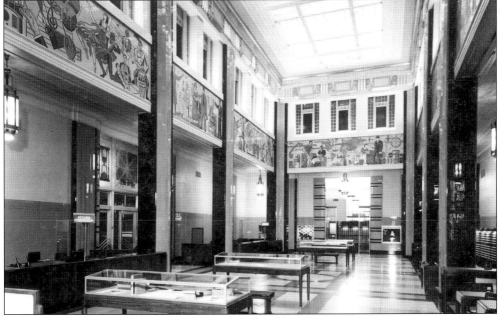

THE CENTRAL ATRIUM. The children's room is decorated with fairy tales, myths, and legends, and the Atrium seen here illustrates different fields of knowledge. The murals designed by John Benson of New York City are six-feet high in a continuous frieze, separated by black and salmon Vitrolite-covered supporting columns. Vitrolite was made in a factory in Parkersburg, West Virginia, and it came in more than 80 colors. (PL.)

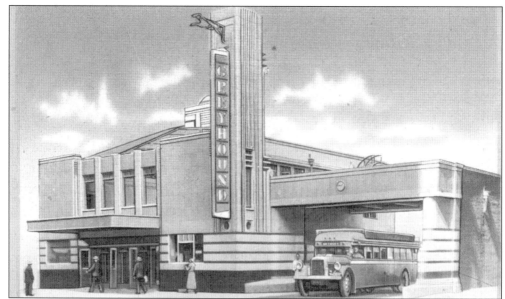

THE GREYHOUND BUS TERMINAL, 414 JEFFERSON AVENUE, BUILT IN 1935 AND DEMOLISHED c. 1959. Greyhound chose the Moderne style for their terminals since the streamlined architecture with rounded corners echoed the shapes of the buses. This structure was built in 1935 to relieve congestion caused by passengers being unloaded from buses on the street. Serving ten bus lines, the building was semi-circular in shape with entrances on both Jefferson and Superior Streets. The waiting rooms were housed in a large rotunda with a glass dome. The structure was designed by architect Willfred Holtzman as a series of primarily horizontal planes featuring geometric decoration of colored tile. This modernistic style represented the last semblance of decorative architecture before the advent of the International Style in the decades ahead. (PL.)

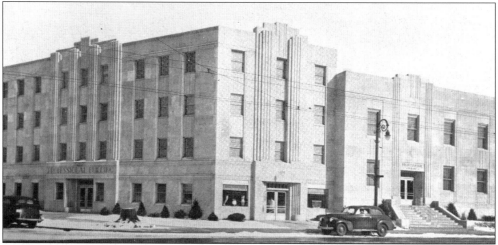

THE PROFESSIONAL BUILDING, MONROE STREET AT PARKWOOD AVENUE, BUILT IN 1939. Architects Tolford and Lange designed a simple limestone building with recessed entrances accentuated by vertical decoration that continues above the roofline. The right section, an earlier building that was modernized to match, has been demolished. The building now houses offices of the Toledo Symphony, The Arts Commission, and The Toledo Museum. (PL)

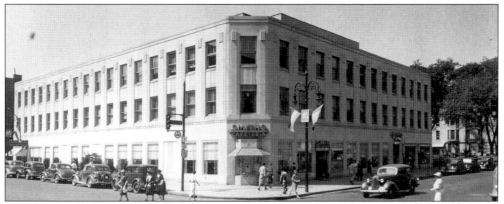

THE BELL BUILDING, 701 MADISON AVENUE AND ERIE STREET, BUILT IN 1936. Toledo businessman Clement O. Miniger, developer of the electric "Auto-Lighter," had originally proposed a 34-story office building on this block, but it was never built because of the Depression. Instead, this smaller limestone building was constructed, advertised as the largest building built in Toledo during the Depression. Rhines, Bellman, and Nordhoff designed a Moderne structure with stripped down neoclassical pilasters between the windows topped by stylized capitals.

Until 1972, the Bell Building was home to Smith's Cafeteria. Grace Smith began her career running the cafeteria at the YWCA with great success, and she opened the Ottawa Hills Tea Room and later the Mayfair on Superior Street, which was to close deeply in debt in 1934. Clement Miniger was so confident in her abilities that he agreed to build the Bell Building to house her cafeteria, coffee shop, service dining room, and pastry shop. It opened in 1936 and was an immediate success, employing a staff of 200 and serving over 1 million meals a year. Specialties included lemon meringue pie, pearl tapioca pudding, and chicken velvet soup. The penthouse of the building housed WTOL-TV for many years.

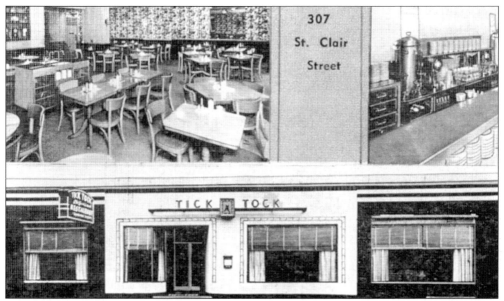

TICK-TOCK RESTAURANT, 307 ST. CLAIR STREET, OPENED IN 1939 AND CLOSED IN 1960. Located behind this streamlined façade in the old Produce Exchange Building, the Tick-Tock was a popular restaurant that primarily served sandwiches and was a favorite with children.

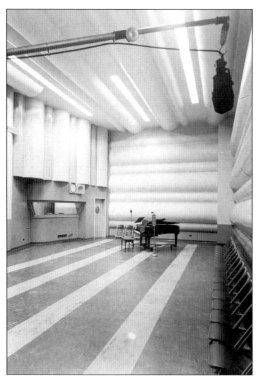

WSPD Radio, 136 North Huron Street, The Broadcasting Studio. By the 1920s, radios were replacing the piano, music box, and gramophone as favorite entertainments in Toledo homes and becoming a new focus in daily life. Toledo's first broadcast took place in 1907 from atop the Ohio and Nicholas Buildings when music and conversation were broadcast back and forth. WTAL, Toledo's first commercial station was established in 1921 with a ten watt radiophone transmitter in the Navarre Hotel. The station was purchased in 1927 by George Storer and his brother-in-law because of their interest in the power of radio advertising, and the call letters were changed to WSPD to advertise Storer's Speedene gasoline, a product he promoted. The station moved to the Commodore Perry Hotel in 1928 becoming the eighth station to join the Columbia Broadcasting System in 1930, and in 1940, it moved to these state-of-the-art facilities on Huron Street. Rhines, Bellman, and Nordhoff designed this broadcasting studio—later the main TV studio. The walls and ceiling are covered with baffles to absorb sound. On the second story of the studio was the sponsor's booth with a window looking down into the studio. The first TV program was aired here on July 21, 1948, and it became the 28th TV station in the nation. The Broadcast Building, as it was later known, housed WGTE. (PL.)

WSPD Executive Offices. The office is wood paneled separated by horizontal bands with curved corners and modern streamlined furnishings. (PL.)

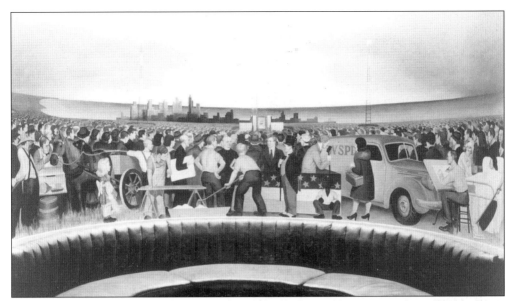

THE WSPD MURAL. This mural was located in the first floor lobby on a circular wall. The subject shows a mass of people from all walks of life gathered as if at a revival meeting to pay homage to the wonders of radio. They face three transmitting towers and a transmitter building in a futuristic city, probably representing Toledo, and above are the words "This light must not fail." The mural, probably painted in 1940, was later removed from the wall and now belongs to WGTE. (PL.)

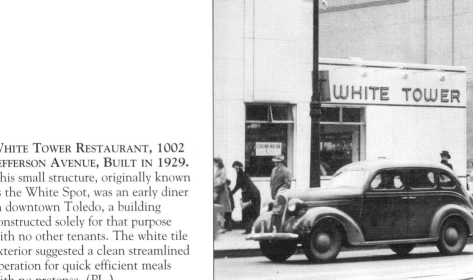

WHITE TOWER RESTAURANT, 1002 JEFFERSON AVENUE, BUILT IN 1929. This small structure, originally known as the White Spot, was an early diner in downtown Toledo, a building constructed solely for that purpose with no other tenants. The white tile exterior suggested a clean streamlined operation for quick efficient meals with no pretense. (PL.)

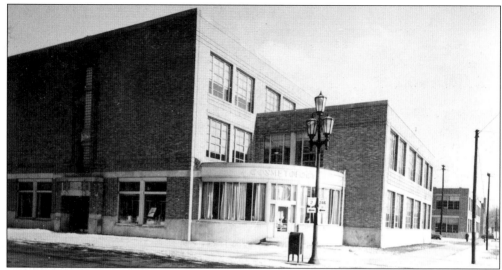

WHITNEY VOCATIONAL HIGH SCHOOL, WASHINGTON STREET AND SEVENTEENTH STREET, BUILT 1939–1941. Toledo's seventh public high school was constructed in conjunction with the Public Works Administration and designed to compliment Macomber High School, constructed in 1938 on the next block. It was named for Harriet Whitney, Toledo's first female teacher. Macomber and Whitney were among the first vocational schools in the country that any boy or girl over 14 years of age who had completed eighth grade could attend. It permitted students to alternate between school and shop, enabling them to gain practical experience and to become self supporting. Designed by Edward Gee, the most distinctive feature of the school was the rounded cosmetology entrance. (Photo by Zink, PL.)

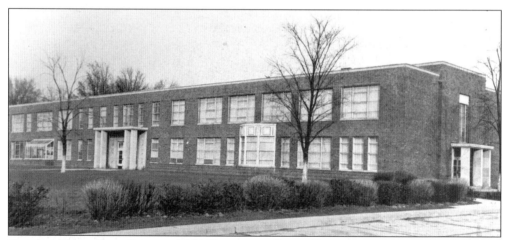

OTTAWA HILLS HIGH SCHOOL, 2532 EVERGREEN ROAD, BUILT 1938–1939. School children in early Ottawa Hills initially went to Monroe School in the Old West End. The first school in Ottawa Hills was a kindergarten through sixth grade housed in the former Grace Smith teahouse at Bancroft Street and Indian Road. The present elementary school was opened in 1930 but after ninth grade, students went to Scott, Devilbiss, or Libbey High Schools. Ottawa Hills first high school, designed by Bellman, Gilette, and Richards, had much in common with school buildings designed by architect Eliel Saarinen at Cranbrook, a private school in the suburbs of Detroit. Common elements include simple square columns, warm brick, and a simple though sophisticated design, altogether very modern looking with practically no decorative detailing. (PL.)

THE INTERSECTION OF CENTRAL AVENUE AND MONROE STREET. This photo from the 1930s shows a former remote suburban crossroads where a few small stores stood with a gas station across the street. The area began to grow during the Depression after Toledo Hospital was built just a few blocks away, and much of Toledo's suburban growth was taking place in this vicinity. To the left is a new commercial building with stores and apartments above. The three-story section was best known as Brauers Deli, which opened in 1952 and was well known for its corned beef, matzo soup, and cinnamon rolls. (PL.)

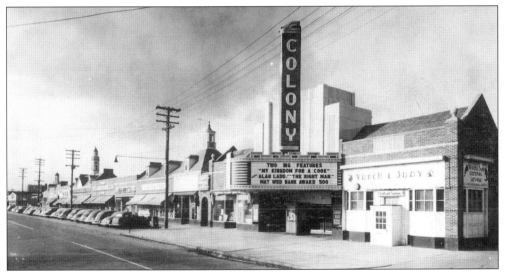

THE COLONY THEATER, CENTRAL AVENUE NEAR OTIS STREET, BUILT IN 1941 AND DEMOLISHED IN 1985. This movie theater was part of the Colony Shopping Center, Toledo's first suburban shopping center. The stores were designed in a colonial revival style, some with hipped roofs, dormer windows, and cupolas. The theater, known as "Tomorrows Theater Today," was a building in the Moderne style with a simple vertical emphasis. The theater closed in 1981 and burned in 1984 before being demolished the following year. The shopping center has also been completely demolished. (Photo by Zink, PL.)

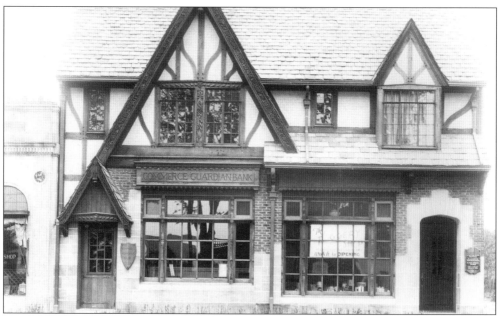

THE COMMERCE GUARDIAN BANK, 1846 WEST BANCROFT STREET, BUILT 1921–1923 AND BURNED IN 1999. The Commerce Guardian Bank first occupied the left side of this building, but it was best known as the Ottawa Tavern, a neighborhood institution long popular with University of Toledo students. Before its destruction in 1999, it was the last significant structure remaining at Bancroft and Upton Avenues. The area was once a thriving intersection of two-story commercial buildings, but all have been leveled for gas stations and carryouts. (PL.)

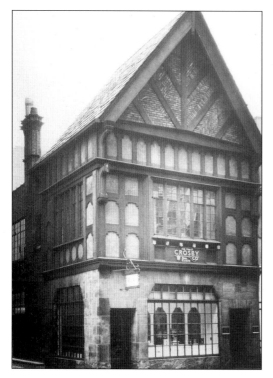

GEORGE CROSBY REALTORS, 413 MADISON AVENUE, BUILT IN1934. Except for the first-floor display windows, the Crosby Realty Building would not be out of place in 16th-century London. The fine half-timbering, slate roof, and chimney pots all contribute to the look of historical accuracy. A distinctive looking building like this often became a good advertising symbol for a business.

FIRST UNITARIAN CHURCH, 2214 COLLINGWOOD AVENUE, BUILT IN 1923. Edward Lewis of Boston was the architect of this church based on Boston's Old North Church. It reflects the 1920s affection for historically inspired architecture when architects liked to design accurate copies of past structures. Located on a street full of churches, it is the only one built with a spire, and the spire contains a clock but no bell. The fine colonial revival sanctuary has a glassed-in room at the back for mothers and babies to sit.

THE CROSBY BLDG, 717 MADISON AVENUE, BUILT IN 1940. Myron Hill was the architect of this 18th-century-style commercial building. It has a bowed window in the center for display and to provide light to the store with a shop door on one side and a door to the second floor at the other side, both with leaded-glass fanlight windows above. Like the Tudor style building on Madison Avenue, this building was also commissioned by the Crosby Realty Company. (PL.)

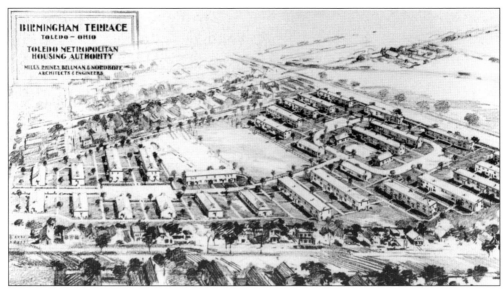

BIRMINGHAM TERRACE IN EAST TOLEDO, BUILT IN 1941. In 1933, the Ohio State Legislature enacted the first housing law creating the Metropolitan Housing Authority, which was authorized to construct and operate low income housing. The Weiler Homes were the first of three projects in East Toledo, and in 1939, plans were begun for a project in the Birmingham neighborhood. Birmingham Terrace was designed by Mills, Rhines, Bellman, and Nordhoff as multi-unit garden apartments in a residential setting. The East Toledo projects were easier to build on vacant land and didn't require slum clearance. In 1953, the first efforts were made to desegregate the all-white projects, and this brought much protest, with nearly 1,000 East Toledoans voting to secede from city. (PL.)

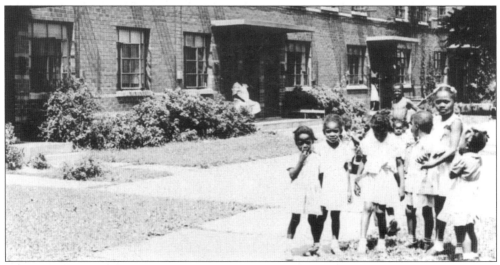

THE BRAND WHITLOCK HOMES, 392 NEBRASKA AVENUE, BUILT IN 1938. The Brand Whitlock Homes was a $3 million project to "provide modern living quarters at low rentals." Some 200 structures were razed for 375 model apartments and row houses with a park and playground facilities. The units were federally funded and owned with rents based on family composition and net income. If a family income reached a certain level, the unit had to be vacated within six months. (PL.)

130

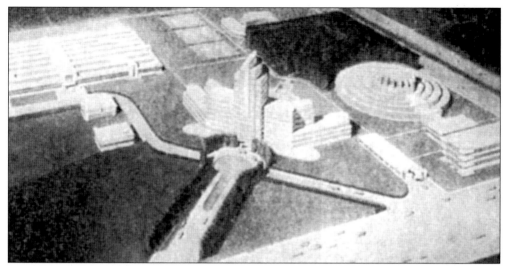

THE PROPOSED ADMINISTRATION BUILDING AND FACTORY FOR THE TOLEDO SCALE COMPANY c. 1929. Norman Bel Geddes, nephew of Toledo Scale Company attorney Frederick Geddes, was a talented designer specializing in stage sets and costumes. He was commissioned by the company to design a corporate campus on their 80-acre property at Laskey and Telegraph Road. He designed separate streamlined futuristic style buildings for each operation. The administration building was to be 14-stories tall with four-story wings. The Precision Devices Building to the right was designed in the shape of a scale. There were also plans for an airfield, and the carefully landscaped complex would have been particularly striking from the air. The campus symbolized the company's policy of introducing beauty in industry. (PL.)

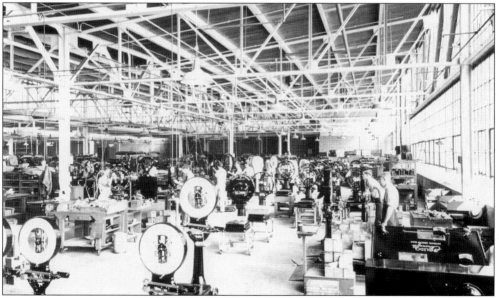

THE INTERIOR OF THE TOLEDO SCALE FACTORY. Allen DeVilbiss, Jr. developed a scale design that abandoned the old balance scale in favor of a scale that relied on a lever and pendulum. This new scale made exact weight a science without the variables of a merchant's honesty and skill factored in. A number of different models are seen here, and most are of a portable variety. Norman Bel Geddes also designed products for Toledo Scale. (PL.)

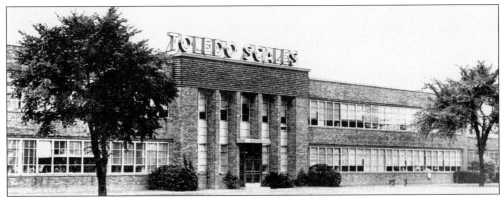

THE TOLEDO SCALE FACTORY, 5225 TELEGRAPH ROAD, BUILT IN 1939 AND BURNED IN 1985. The factory was located in six different plants before they were consolidated into this five-acre building. Albert Kahn Inc., the renowned Detroit architectural firm, designed the combination factory and administration building at a third of the cost of Norman Bel Geddes 1929 project. The first floor contained the research and engineering departments, and the second floor housed sales and accounting. (PL.)

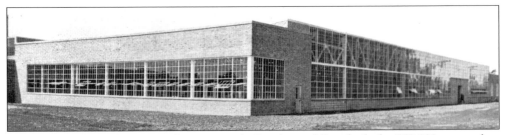

THE TOLEDO SCALE FACTORY. Contractors A. Bentley and Sons built the 550,000-square-foot building in only six months. Manufacturing operations were located in four glass and concrete factory sections. Additions were made to the plant in 1941 for defense work. In 1965, it was seriously damaged in the devastating Palm Sunday Tornado. After the plant closed the building, then known as the Willis Day Business Center, burned in what turned out to be the largest fire in the United States in 1985 with a $20 million loss. (PL.)

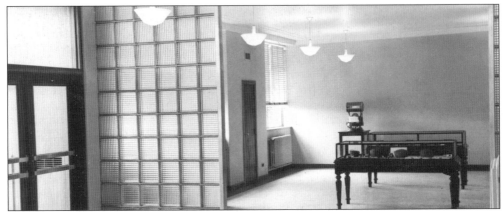

THE INTERIOR OF THE ADMINISTRATION BUILDING. Walls were constructed of innovative glass block with the companies' products displayed in cases. The company employed 1,350 people until the plant moved to Columbus, Ohio.

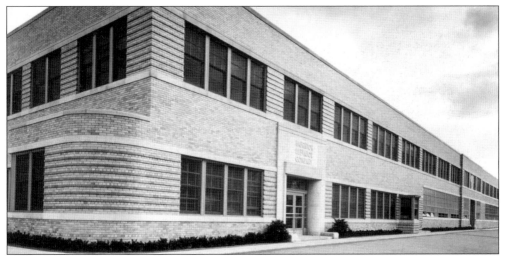

HOUGHTON ELEVATOR COMPANY ADMINISTRATION BUILDING, 671-93 SPENCER STREET, BUILT IN 1940. The company was founded in 1867, and by the mid 1880s, it specialized in elevators and later hydraulic and steam escalators. Houghton Elevator installed the elevator at the rocket launching pad at Cape Canaveral. The company merged with Toledo Scale in 1957 and was purchased by Shindler Holding in 1979.

This was the new office and engineering building designed by Mills, Rhines, Bellman, and Nordhoff in 1940. It was described by a contemporary source: "The exterior will be light red in color. Horizontal lines will be stressed with projecting brick courses running horizontally around the structure. The trim will be of buff Indiana limestone. Large amounts of glass area, big windows with small brick piers, will provide a maximum amount of interior lighting in line with the modern conception of utilitarian factory construction. The name of the company will be carved in stone over the entrance."

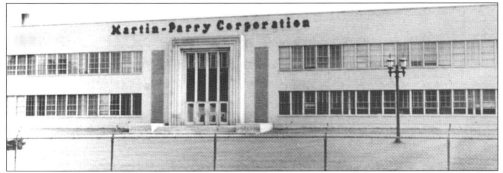

AMERICAN PROPELLER CORPORATION FACTORY, 1455 WEST ALEXIS ROAD, BUILT IN 1942. This war plant was constructed in 110 days and manufactured propellers out of an innovative lightweight seamless steel tubing used on the navy's Pacific theater Hell Diver bomber, the first cannon-firing plane. William Wise, the president of the company said, "Today we are going to send into battle new and different steel blades, from a different city of Toledo; and it is our hope that our Toledo blades will achieve the same reputation, in the battles of today that was enjoyed by the old Toledo blades of long ago." The plant was patrolled by 90 special guards.

After the war, it was purchased by Martin-Parry, a Detroit firm making Rexair cleaner and conditioner and prefab partitioning for industrial, residential, and ship construction. In 1955, the factory was purchased by General Motors Corporation and made automatic transmissions for passenger cars. (PL.)

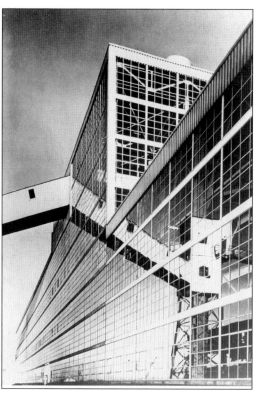

THE LIBBEY OWENS FORD GLASS COMPANY FACTORY, ROSSFORD. Edward Ford was an old hand at glass manufacturing when he moved to Toledo in 1898, buying 25 acres near East Toledo to establish a new glass factory. He founded the company town of Rossford, building 66 cottages that the company rented to its employees. The Edward Ford Plate Glass Company later merged to form Libbey Owens Ford, and the company was sold to Pilkington Glass in 1987.

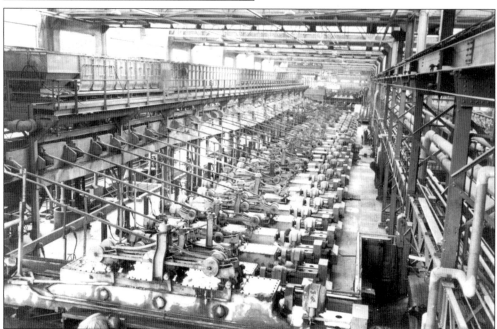

LIBBEY OWENS FORD FACTORY INTERIOR. This was part of the largest plate glass company in the world, making some 4 million square feet of glass per year and employing 700 men day and night. The twin grinding plant was built after World War II with two giant lines, transforming the old glass grinding and polishing lines into a high-speed polishing plant. (PL.)

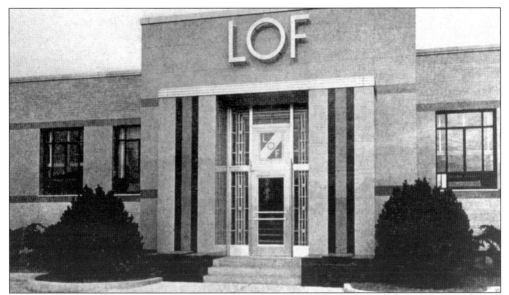

LIBBEY OWENS FORD TECHNICAL BUILDING, BUILT IN 1936. Mills, Rhines, Bellman, and Nordhoff designed LOF's research lab and covered it with Vitrolite. Originally made in Parkersburg, West Virginia, the company was purchased by LOF in 1935. It could be made in many colors and textures and could be used to great effect for dressing up a tired storefront. It was also used for interior partitions, wainscoting, bathrooms, kitchens, and of course the famous library murals. Vitrolite manufacturing ended in 1956 due to competition from other building materials that were easier to install.

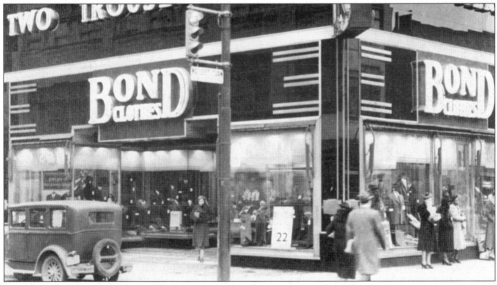

BOND CLOTHES, 500-02 ADAMS STREET AND SUPERIOR STREET. The Mills firm designed a number of Vitrolite covered facades, recognizing what great effects could be achieved. This structure was the old neoclassical style Dime Savings Bank Building, but with the wonders of Vitrolite, it re-emerged after a 1936 fire as the glamorous looking Bond Clothing Store. Bond's was a New York based chain with some 160 locations, and they had a store at this site from 1931 until 1973. (PL.)

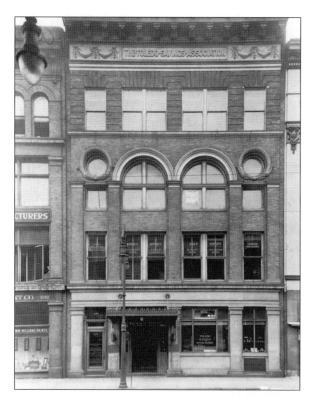

THE TOLEDO SAVINGS ASSOCIATION, 228-30 SUPERIOR STREET, BUILT IN 1899-01. This Beaux Arts-style bank was considered dated looking by the end of the 1930s.

THE UNITED BUILDING, 228-30 SUPERIOR STREET, DEMOLISHED IN 1984. The old building was altered in about 1936 by Karl Hoke with black Vitrolite panels streaked with seams of green, framing vertical brass piers. This is one of the few examples of an old building being arguably improved by modernization. A talented architect such as Karl Hoke was able to create an elegant new facade and not make it look like it was just covering something over as most remodeling jobs on older buildings do. Later known as the Hankison Building, it was demolished with the rest of the block to provide a site for a corporate headquarters that was never built here, and it has remained a parking lot ever since.

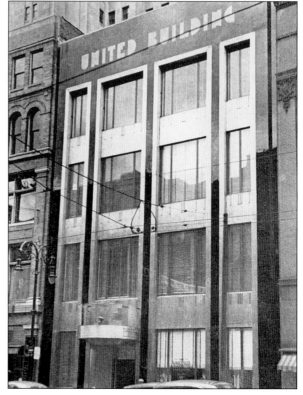

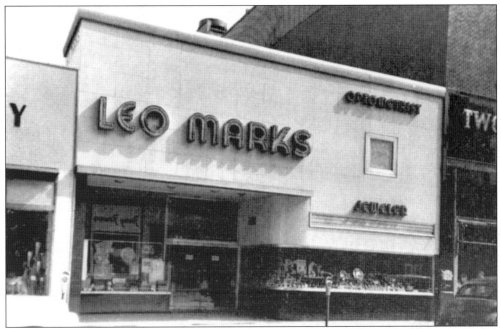

LEO MARKS JEWELERS, 508 ADAMS STREET. The facade designed by Herman Feldstein for jeweler and optometrist Leo Marks dated from the late 1940s and illustrated the continued popularity of the Viotrolite look. Here it is embellished by a bold sign and a traditional jewelry store clock set into the facade in an interesting manner. The building was demolished in 1985. (PL.)

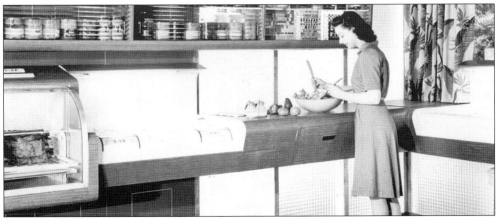

LIBBEY OWENS FORD'S KITCHEN OF TOMORROW. The kitchen was designed in 1943 by H. Creston Doner, Director of Design, as the kitchen to end all kitchens. Advertised as "a post-war home design that writes an emancipation proclamation from kitchen drudgery for the American housewife," it had breathtaking innovative features. It was a room of smooth glass surfaces with a horizontal refrigerator with glass doors, and a stove with a clear glass cover that had a built-in waffle and sandwich grill and recessed wells to steam food. Recessed cooking utensils replaced pots and pans. Self-illuminated Vitrolite splash panels concealed all equipment when not in use. Three quarters of the work could be done while seated, and the room could be converted into a playroom, study, buffet, or bar. The Kitchen went on a tour of the nation and was seen by two million people. In 1984, it became part of a traveling exhibit of the Smithsonian Institution. (Photo by Hedrick-Blessing Studio, PL.)

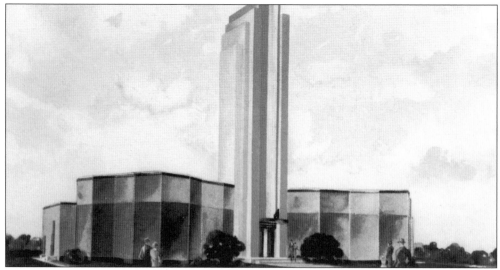

THE OWENS-ILLINOIS BUILDING AT CHICAGO'S CENTURY OF PROGRESS EXPOSITION, BUILT IN 1933. To most people this structure was their first introduction to glass block, first developed in 1930, though not available to the public until 1935. The building was 100-feet long, and 60-feet wide, with a 50-foot tower. The glass blocks were coated on five sides with different colors of cement paint, so the color of the building changed with changes in sunlight and at night with electric lights.

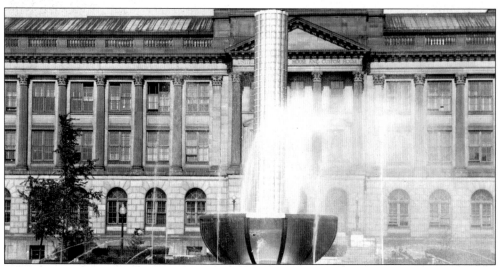

THE CIVIC CENTER GLASS FOUNTAIN, BUILT IN 1942 AND DEMOLISHED IN 1965. Located on the Civic Center Mall, the fountain was designed by architect Robert Deigert and sculptor Walter Johnson. It was conceived by business leaders and officials of WSPD radio as a symbol of modern Toledo and the high level of technology and ingenuity achieved by Toledo's glass companies.

The fountain was strikingly modern in appearance; it had a 35-foot tower of glass blocks in a large glass bowl, surrounded by a circular pool with jets of water shooting 17 feet into the air.

From the time of its dedication, the fountain was beset with problems. Leaks were discovered, and one spout failed to shoot water as high as the rest. The fountain was rarely in good repair, and no city funds could ever be found to renovate it. The tower was removed in the late 50s, and the rest of the fountain was demolished in 1965. (PL.)

Six

THE SPACE AGE

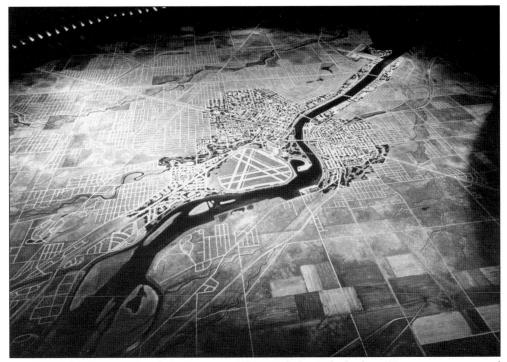

TOLEDO TOMORROW. This futuristic view of how Toledo might look in 50 years was promoted by *Blade* Publisher Paul Block, Jr. as "a grand scheme to rebuild Toledo from a smoky Lake Erie town into an ultra-modern, beautiful transportation hub." The project was designed by Norman Bel Geddes and Associates, best known for their innovative concepts in streamlining industrial design and for their "Futurama" display at the 1939 New York World's Fair. *Toledo Tomorrow* opened in 1945 and was viewed as one of the boldest examples of urban planning in America at that time, and it made the cover of *Life Magazine*.

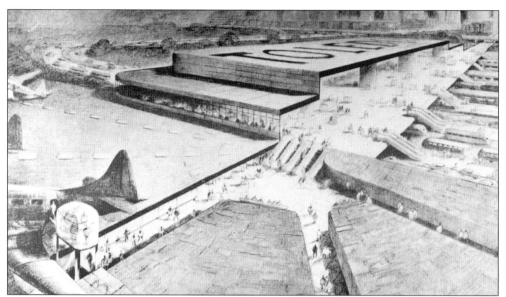

THE PROPOSED UNION TERMINAL. A brochure on the exhibition stated, "Air liners from the far corners of the world make connections with trains and inter-city busses in the Union Terminal of TOLEDO TOMORROW . . . In this drawing, Artist Hugh Ferriss shows how railroad, air, and bus lines can be served by a common passenger terminal." The idea of a downtown airport was unheard of; the only space for airports was generally far from city center and often took as long to get from home to the airport as to fly to ones destination.

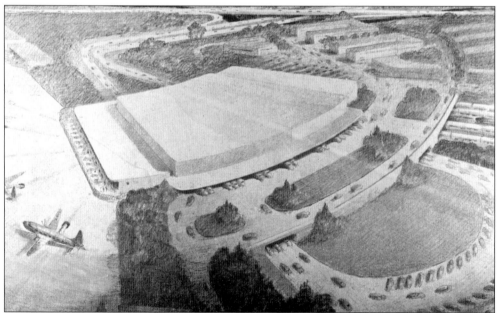

A CROSS SECTION OF THE PROPOSED UNION TERMINAL. "This cross section view of Toledo Tomorrow's tri-terminal shows how passengers descend by escalators from terminal's main concourse to waiting trains, buses, and air lines. . . . At the left passengers are being brought to their plane by elevator from tunnel below. . . . Trains are receiving and discharging passengers in the right background behind the bus loading ramps."

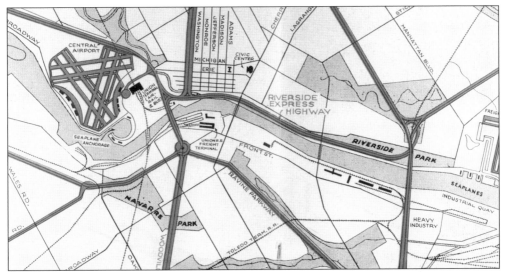

TOLEDO TOMORROW'S PROPOSED MAP OF DOWNTOWN. The big transportation hub would be in the Middle Grounds area, and a series of below-ground expressways were planned. The plan called for beautification of the waterfront with provisions made for the arrivals and departures of seaplane travelers. A great deal of attention was paid to quality of life issues and living conditions for the population: "Inefficiency and waste are like chains holding a city back from progress. Business can not grow when potential customers are repelled by an ugly, traffic-jammed downtown district and go to other cities or other sections for their needs." The project would have required demolition of an enormous part of the city.

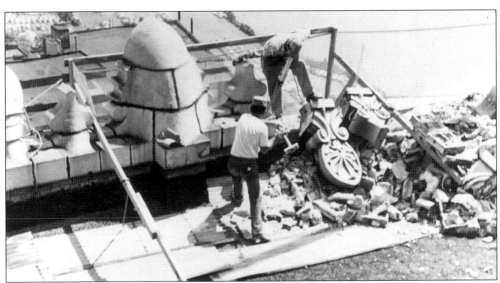

THE DEMOLITION OF THE SECOND NATIONAL BANK BUILDING CORNICE. Workmen are busy destroying the glazed terra cotta cornice on architect D.H. Burnham's Second National Bank Building at Summit Street and Madison Avenue in 1954. Many downtown buildings were stripped of decorative detailing and covered over with false fronts during attempts at "modernizing" after World War II. Most of these alterations ended up looking much more dated than if the building had just been left intact. "Improvers" couldn't leave this building alone, and the lower floors were stripped of decoration and refaced in 1966. (PL.)

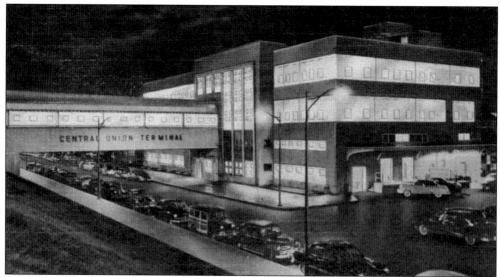

CENTRAL UNION TERMINAL, AT THE FOOT OF KNAPP STREET, BUILT 1947–1950. A result of the *Toledo Tomorrow* exhibition was a renewed interest in replacing the antiquated 1880s station, which should have been replaced at the turn of the century. In 1944, the Planning Commission wrote, "It is almost a crime to repeat what has been said so many times, that the first impression of a city one has, is formed upon the entrance to the city, and that invariably the opinion of strangers arriving at the Union Depot is bad."

Designed by architect Robert Corsbie, the new station cost $5 million and covered 25 acres with 55 daily departures from six passenger platforms. The building was known as the "Palace of Glass" and had an 80-foot long barrel vault overpass. The Station was sensitively renovated in 1996.

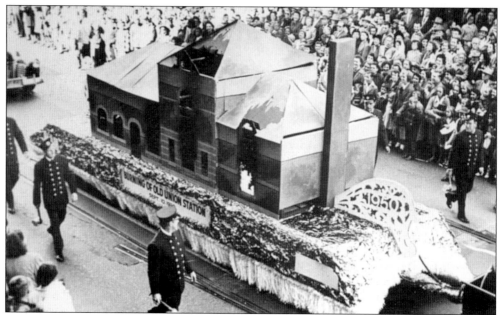

A MODEL OF THE OLD UNION STATION ON FIRE. A parade was held on opening day where a model of the despised old Union Station was set on fire to commemorate the 1930 conflagration when hundreds of spectators gathered to root for the fire. (PL.)

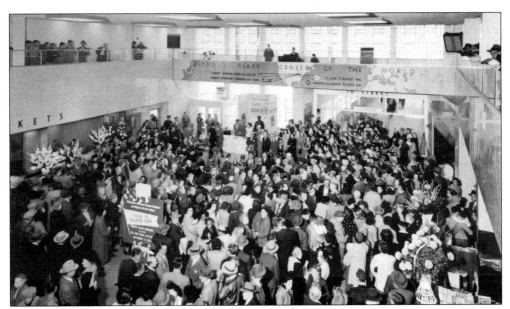

OPENING DAY IN THE LOBBY AT CENTRAL UNION TERMINAL. A critic wrote, "The new station structure will reflect the modern trend in architecture through the use of simple functional architectural composition and the employment of large glass areas, bold color schemes for interiors, and the use of aluminum and stainless steel trim. . . . Liberal amounts of plate glass, glass blocks, double-glazing, and tempered glass doors are used throughout the building." The lobby was faced with Vitrolite panels, including a map of the world with Toledo located at the center with the title "Glass Center of the World." (PL.)

TOLEDO EXPRESS AIRPORT, BUILT IN 1954. Unfortunately inclement weather prevented flights from taking off and landing on opening day January 5, 1955, and the dedication in October had taken place during a freak snowstorm. Toledo had three small airports: one at Alexis and Telegraph Roads, Franklin Field at Talmadge and Monroe Streets, and Muncipal airport, which opened in 1928 and was bought by the city in 1936. A *Blade* editorial wrote that the new $3.8 million airport was "a monument to the determination of the residents of a modern industrial city to have a modern airport and to the initiative of a group of its business and industrial leaders who cut through the snarls that always got in the way of earlier efforts to improve this cities situation in relation to air transport." (PL.)

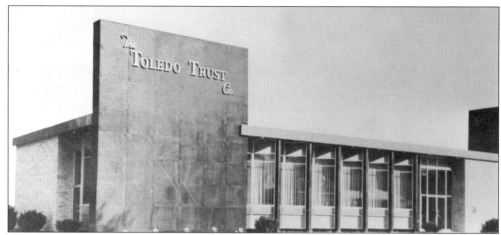

TOLEDO TRUST COMPANY, 3030 SECOR ROAD, BUILT IN 1956. The bank was constructed at the same time as the Westgate Shopping Center across the street. The design consisted of two pylons of black veined marble with bronze signs, and the rest of the building was constructed of light gray brick with thermopane glass. The west wall had angled brick walls in a jalousie effect to diffuse the afternoon sun. Architects Bellman, Gillette and Richards had a talent for designing small elegant buildings employing rich materials.

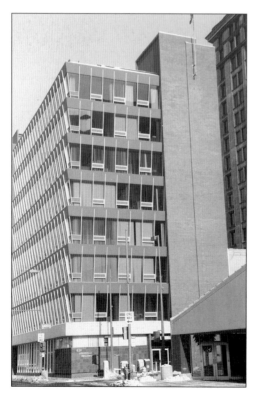

HOME BUILDING AND SAVINGS, 622-28 MADISON AVENUE AND ERIE STREET, BUILT 1959–1960. This was the main office of a savings and loan firm established in 1887. St. Louis architect William Cann designed Toledo's first primarily glass structure anchored by a rectangular brick tower housing elevators, stairs, and duct space. The *Blade* wrote, "The plate glass will be canted inward to achieve a unique tiered jewel box effect." (PL.)

2245 Marengo Street, Built in 1942. Ranch houses were first developed in early 1930s as the future house of choice for those moving to the suburbs. The homes were cheaper, and "even a poor architect has a hard time making a spreading, one story house unattractive." This good example was designed by William Henry Buderus, a promising young architect who was one of 1,195 Toledo men killed during World War II when his ship was sunk in the Battle of the Philippine Sea. (PL.)

The Morris House in Rossford, Built in 1949. Another ranch house of stone, glass, and shingles suggests a strong Frank Lloyd Wright influence with a strong horizontal emphasis, wide eaves and a large chimney. M. DeWitt Grow was the architect. (PL.)

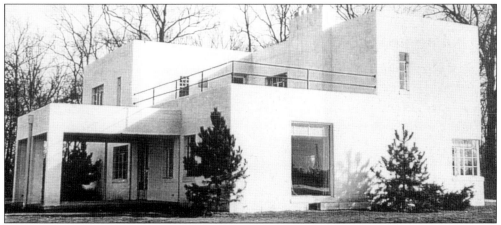

Lyman Goodbody House, Built in 1937. This was a rare example of an early International Style house, the style was developed in France and Germany and characterized by flat roofs and devoid of any decorative detailing or emphasis on the beauty of the building materials. Simple geometric shapes were combined to create an interplay of projections and voids.

145

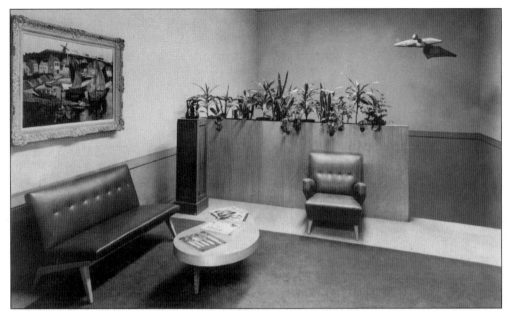

THE MEMBERS LOUNGE AT THE TOLEDO MUSEUM OF ART. This photo dates from about 1960 and shows examples of contemporary furniture design, including a kidney shaped coffee table and upholstered furniture geometric in shape with angled legs. (TMA.)

BUNNYVILLE AT THE TOLEDO ZOO. The restoration of Colonial Williamsburg had a profound influence on American residential architecture, and while architects would like to have popularized more contemporary designs, Toledo's middle classes felt more comfortable with the traditional, colonial revival looking houses like those in Bunnyville.

Students at Macomber High School constructed the 30-scale model buildings that made up Bunnyville, complete with a church, restaurant, fences and paths, a water powered mill, and actually one or two contemporary-looking buildings. The exhibit opened in 1939 and was populated by a group of rabbits. (Metroparks.)

146

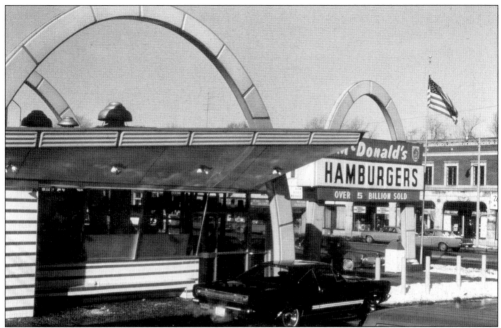

MCDONALD'S RESTAURANT, 3345 MONROE STREET, BUILT IN 1962. The McDonald brothers began their careers running a hot dog stand in the late 1930s and later opening a drive-in barbecue in San Bernardino, California. In 1948, they fired the carhops, streamlined their menu, and mechanized everything in their kitchen for faster food preparation. Their new concept was based on speed, lower prices, and volume. The golden arches were Richard McDonald's idea: "I thought the arches would sort of lift the building up. . . . Our architect said, 'Those have to go,' but they worked." The restaurant became part of a new roadside culture, and the soaring arches, bold bright and modern-looking were meant to get the motorists attention. This was Toledo's first McDonald's, and it lasted almost 30 years before it closed in 1992.

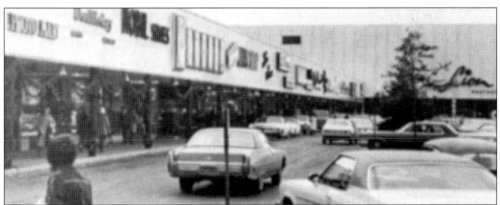

WESTGATE VILLAGE SHOPPING CENTER, 3301 WEST CENTRAL AVENUE, BUILT 1956–1957. The idea of the shopping center was popularized by Addison Mizner in the 1920s on Worth Avenue in Palm Beach. The shopping center was really just the recreation of one side of a downtown main street with a big parking lot next to it. Westgate is a strictly functional postwar shopping center open to the elements and lacking the fantasy element that early shopping centers had. It opened in 1957 with 23 stores, Smith's Cafeteria, and the Lion Store. The nondescript buildings were enlivened by their individual signs with each store defining itself from its neighbors.

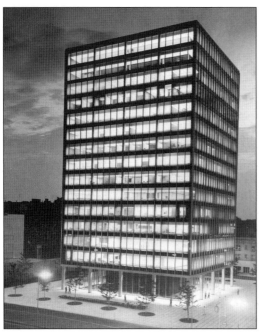

LIBBEY-OWENS-FORD BUILDING, 811 MADISON AVENUE, BUILT IN 1960. New York architects Skidmore, Owens, and Merrill were chosen to design this International Style building, the first skyscraper constructed in Toledo in 30 years. The International Style, originated by German born architect Mies van der Rohe in the 1930s, follows the concept that "less is more." By including little, if any, decorative detailing on a building, there is less for the eye to be distracted by, and the building's overall impact will be more powerful. Buildings designed in the International Style make no attempt to conceal their steel skeleton with a veneer of brick or stone like the Public Library and Safety Building. A large plaza leads to the recessed first floor, indented to give the impression that the 15-story building is weightless—practically rising off the ground like a spaceship.

The building was the first Toledo example of how zoning changes allowed buildings to be built taller if they were surrounded by open plazas. When this building was completed, it must have been absolutely striking to look at—this dramatic open space surrounded by conventional commercial buildings with first-floor commercial spaces. Unfortunately after a few decades every new building was designed with its own open plaza, and they knocked the life out of formerly vibrant city blocks by spoiling the integrity of the street line. LOF sold the corporation and their headquarters to the British glassmaking firm of Pilkington Brothers in 1986.

BOARD ROOM. This view is looking from the lounge into the conference area through tempered and laminated Parallel-O-Grey Glass. The look of luxury and efficiency are conveyed through the choice of materials and fine design down to the smallest detail.

SOUTH ENTRANCE LOBBY PHOTO. This photo shows how the terrazzo paving on the plaza was carried through into the lobby, thus further blurring the division between outdoors and indoors. The plaza was kept simple, planted with honey locust trees, and it was heated to melt ice and snow. The lobby has beautiful 20-foot high blue glass mosaic walls.

THE PRESIDENTS OFFICE. The office was paneled in teak with a matching desk and cabinet with travertine top. (All Photos by Hedrich Blessing, PL.)

THE MEDICAL COLLEGE OF OHIO, 3000 ARLINGTON AVENUE, BUILT 1975–1979. The Medical College of Ohio was established by the Ohio General Assembly in 1964. During the 1950s, Toledo had a severe shortage of doctors, and in 1954, the city requested state funding for reinstitution of a medical college. The funding was approved the following year, and a 150-acre site was chosen on the grounds of the old State Hospital. The first 32 students began classes in 1969.

This view shows the Medical College Hospital (1979) to the right and the Mulford Library (1975–1976) to the left. Both buildings were designed by Don Hisaka and Associates of Cleveland and Rossi and Nickerson of Toledo. (PL.)

URBAN RENEWAL AT THE TOWN HALL THEATER. Here is a rather poignant scene during the demolition of Rose La Rose's Town Hall Burlesque Theater in 1968. Under the name of urban renewal, one fifth of downtown Toledo was demolished, with as many buildings lost as some European cities after World War II bombing. Many sites were used for new buildings, but many others have remained empty ever since. (PL.)

150

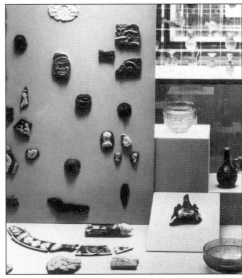

(*above, left*) THE TOLEDO MUSEUM OF ART GLASS GALLERIES, OPENED IN 1970. The gallery was made possible with money donated by Mr. and Mrs. Harold Boeschenstein and provided space to display about one third of the museum's renowned 6,000-piece glass collection. The space was designed by Ford and Earle of Detroit with white marble walls and a ramp leading from ancient glass to the European and American collection on the second floor.

A new $25 million glass gallery designed by the Tokyo firm of SANAA Ltd. is currently planned on a site across the street from the museum. The new building will have a glass furnace, a café, and less space for displaying the collection. The old gallery is currently closed awaiting demolition. (TMA.)

(*above, right*) A GLASS GALLERY DISPLAY CASE. This case displayed ancient Roman glass fragments. A contemporary source wrote, "They are now displayed in all of their glittering elegance in dramatically lighted display cases." (TMA.)

(*right*) ONE GOVERNMENT CENTER, JACKSON STREET AND HURON STREET, BUILT IN 1983. This is the second building in Toledo designed by Yamasaki and Associates of Detroit, the other being the Health Science Building at the Medical College. This building is a perfect illustration of what happens when there are no architectural competitions held to design major public buildings like in the past, so there is no incentive to create anything special. Designed by the architects of the World Trade Center Towers, the building is only about 30 percent glass with narrow lancet windows, suggesting an old IBM computer punch card and unintentionally paying tribute to the government beaucracies it houses. Yamasaki had a personal fear of heights and explained his use of the narrow windows, "You have a sense of acrophobia looking out from an all glass building. There is a feeling you're going to fall out."

OWENS CORNING FIBERGLAS TOWER, 319 MADISON AVENUE AND ST. CLAIR STREET, BUILT IN 1969. Designed by Harrison and Abromovitz, a New York architectural firm, the 30-story Fiberglas tower is a rather typical example of the International Style. The style is termed "International" because it can be built anywhere, without thought to the surrounding climate or geography. The construction of the adjoining Levis Square on the site of the old Post Office helps to alleviate the tower's sense of dark impenetrability. The building has been vacant for at least five years, but still generates income from antenna rentals on the roof.

OWENS-ILLINOIS CORPORATE HEADQUARTERS, 614 SUMMIT STREET, BUILT IN 1981. The 32-story Owens Illinois Headquarters, Toledo's most recent glass skyscraper and probably the last one to be built for a long time, makes a bold statement at the northern edge of the downtown Toledo's skyline. Designed by architects Abromovitz, Harris, and Kingsland, the building is shaped like a large "I" with an "O"-shaped lower building housing an auditorium and cafeteria. Like Toledo's first glass skyscraper, the 1960 LOF Building, the Owens Illinois Headquarters is a fitting symbol of Toledo's major product and was an integral element in redevelopment plans for downtown and the riverfront.

PORTSIDE, 400 SUMMIT STREET, BUILT IN 1984. Toledo had three suburban shopping centers, but this was the first one located downtown. Portside was part of the Seagate Development, which included the new Owens-Illinois Headquarters, a 250-room hotel, and two office buildings. Rouse, the developer, felt that the way to revitalize the downtown area was to create large, clean shopping and entertainment centers to lure people downtown. Malls like Portside were seen as a refuge containing, according to one critic, "no unsavory bars or pornography shops, no threatening-looking characters, no litter, no rain, and no excessive heat or cold, a brightly lit, poverty-free theme park version of the darker, less savory versions of the downtown, it was supposed to revitalize." The mall closed in 1990 and reopened in 1997 as The Center of Science and Industry.

SUMMIT CENTER, 333 NORTH SUMMIT STREET, BUILT IN 1987. One welcomes this building, constructed all the way to the sidewalk, for attempting to maintain some integrity of the street line in a city chock full of parking lots and buildings with open plazas, or buildings where all surrounding buildings have been intentionally torn down to make them look like a free standing buildings in a suburban office park.

McMaster Hall at the University of Toledo, Built in 1987. The University has wisely attempted to make their new central campus buildings relate stylistically to the older ones. McMaster Hall, home to the physics and astronomy departments, was designed by Munger, Munger, and Associates. It has strong post-modern elements such as the sharply pointed pediments with round windows, but the textured stone assimilates well with the venerable University Hall and other surrounding buildings.

Nitschke Hall, Built in 1995. Architect Richard J. Fleischman of Cleveland designed a very modern structure for the College of Engineering at the southeast edge of the campus. The building displays a pleasing grid pattern, and the use of colored glass is very effective. The University of Toledo campus has some of the best contemporary architecture being built anywhere in the city.

154

THE UNIVERSITY OF TOLEDO, CENTER FOR THE VISUAL ARTS AT THE TOLEDO MUSEUM OF ART, MONROE STREET AT SCOTTWOOD AVENUE, BUILT 1992–1994. Frank Gehry is one of the leading proponents of De-constructivism, a philosophy that rebels against the International Style philosophy of "form follows function." Gehry's characteristic designs are rambling structures with lots of superfluous decoration exploding out at the viewer, as insignificant to the structural integrity of the building as gingerbread was to Victorian houses. Having a Gehry-designed building in one's city is considered an important status symbol.

This design is less flamboyant and more conservative than some of his others. He attempts to harmonize with the Museum building in height, proportions, and in the size of the panels of its delicate metal skin. A museum source stated, "[It] incorporates many of his outstanding architectural interests: energetic sculptural effects, the innovative use of building materials, dynamically conceived internal spaces, an extraordinary feel for light and space, and a modernist interest in the phenomena of perception."

CENTER FOR THE VISUAL ARTS. The inside of the "V"-shaped structure is a glass enclosure with two staircase towers and a courtyard surrounded by a low wall of glass, enclosed with a curtain wall of green glass. The four-story structure houses classroom space for the University's Art Department. Frank Gehry also designed the Center for Sculptural Studies across the street, a plain concrete structure reminiscent of the Berlin Wall.

155

THE OWENS CORNING HEADQUARTERS, 1 OWENS CORNING PARKWAY, BUILT IN 1996. This new $100 million headquarters for Owens Corning, a company founded in 1938 by Owens-Illinois and the Corning Glass Works, was constructed on the historic Middle Grounds, the former site of much of Toledo's railroad activity in the mid 19th century. While located in the downtown area, this sprawling building housing 1,200 workers is like a horizontal skyscraper in a campus-like setting.

The building makes use of historical architectural precedent; this entrance suggests a Mayan temple.

OWENS CORNING HEDQUARTERS. The architect made good use of materials and patterned wall surfaces; other parts of building are primarily of glass. The brick tower with its porthole windows is an interesting detail. Covered walkways and projecting cornices assimilate the indoors with the outdoors. Architect Caesar Pelli is best known for his work as chief architect of the major office buildings at Battery Park City in Manhattan and for his elegant designs and good use of quality materials.

INDEX

BIBLIOGRAPHY

A. Bentley, and Sons Co. *Building Construction*, 1913.

Bel Geddes, Norman, and Associates. *Toledo Tomorrow*, 1950.

Brady, Frank. "The Publisher and the Showgirl," *The Blade*, Aug. 22, 1999.

Brickey, Homer. "Perry's Impressions Endure," *The Blade*, Nov 24, 1996.

Brown, Joe E. *Laughter is a Wonderful Thing*. New York, NY: A.S. Barnes and Company, 1956.

Carl E. Mehring Co. *Toledo Homes of Distinction*. Promotional Item, The Carl E. Mehring Co., n.d.

Cound, J.C. *The Henry Spieker Co.* Toledo: Wenzel Printing Co.

Doordan, Dennis P., ed. *The Alliance of Art and Industry: Toledo Designs for a Modern America.* New York, NY: Hudson Hill Press, 2002.

Dorn, Richard. "The Works Progress Administration in Toledo, Ohio: Local initiatives for Federal Aid during the New Deal, 1935–43," *Northwest Ohio Quarterly*, Vol. 67, No. 4, Autumn 1995.

Floyd, Barbara. *A Walking Tour Guide to UT Architecture.* Toledo, OH: University Archives, Ward Canaday Center, University of Toledo, 1987.

Illman, Harry. *Unholy Toledo.* San Francisco, CA: Polemic Press Publications, 1985.

Johannesen, Eric, and Allen Dickes. *Look Again.* Pittsburgh, PA: Ober Park Assoc Inc., 1973.

Karl Buckingham Hoke Architect, Architecture and Design, 1937.

Killits, John. *Toledo and Lucas County Ohio 1623–1923.* Chicago, IL: S.J. Clarke Publishing, 1923.

Lamb, Edward. *No Lamb for Slaughter.* New York, NY: Harcourt, Brace and World Inc., 1963.

Larson, James, and James Reeve. "Toledo Churches," *Northwest Ohio Quarterly*, Vol XLIV, Spring 1972.

Lewis, Ethel. "Drawing Room in Lockhart McKelvey Home," *Toledo Times*, August 26, 1933.

Ligibel, Ted. *The Toledo Zoo's First 100 Years.* Virginia Beach, VA: The Donning Co., 1999.

Ligibel, Ted. "Where Modern Was," *The Blade*, February 9, 1992.

Patterson, Grove. *I Like People.* New York, NY: Random House, 1954.

Mills, Rhines, Bellman, and Nordhoff. *Selections form the Work of Mills, Rhines, Bellman, and Nordhoff, Architects and Engineers.* Toledo, n.d.

Richards, Bauer, and Moorhead. *Richards, Bauer, and Moorhead/80 years of Architecture.* Firm's Promotional Item, c. 1970.

Roetenik, C. *Toledo Telephone Facts.* Feb. 15, 1954.

Smith, R. Boyd. *The Best of Smith's Cookbook.* n.d.

Spitzer, Doreen Canaday. *By One and One.* Canaan, NH: Phoenix Publishing, 1984.

Staelin, Carl. "The Toledo Club Story," *Toledo Club News*, February 1972.

Stevenson, Lynn. "Clare Hoffman: Usually Right," *The Blade*, April 17,1977.

Terry, Bob. *Honest Weight—The Story of Toledo Scale.* Xlibris Corp., 2000.

Thomas, Danny with Bill Davidson. *Make Room for Danny.* New York, NY: G.P. Putnam's Sons, 1991.

Toledo Centennial Commission. *This is Toledo.* Toledo, OH: Toledo Centennial Commission, 1937.

Toledo and Lucas County Plan Commissions. "What About Our Future?" Report, December 8, 1944.

Tong, Benson. "Ottawa Hills: A Garden-Style Community," *Northwest Ohio Quarterly*, Vol. 68, No. 2, Spring 1996.

Newspapers:

The Toledo Blade, The Toledo News-Bee, The Toledo Times